IMAGES
of America

EDGEWATER

D1511997

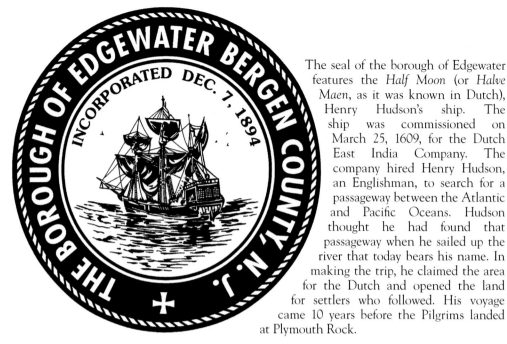

The seal of the borough of Edgewater features the *Half Moon* (or *Halve Maen*, as it was known in Dutch), Henry Hudson's ship. The ship was commissioned on March 25, 1609, for the Dutch East India Company. The company hired Henry Hudson, an Englishman, to search for a passageway between the Atlantic and Pacific Oceans. Hudson thought he had found that passageway when he sailed up the river that today bears his name. In making the trip, he claimed the area for the Dutch and opened the land for settlers who followed. His voyage came 10 years before the Pilgrims landed at Plymouth Rock.

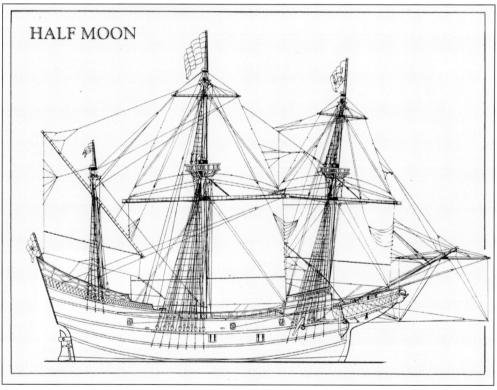

HALF MOON

IMAGES
of America

EDGEWATER

Douglas E. Hall with the
Edgewater Cultural &
Historical Committee

ARCADIA
PUBLISHING

Copyright © 2005 by Douglas E. Hall with the Edgewater Cultural & Historical Committee
ISBN 978-0-7385-3725-2

Published by Arcadia Publishing
Charleston, South Carolina

Printed in the United States of America

Library of Congress Catalog Card Number: 2004113374

For all general information contact Arcadia Publishing at:
Telephone 843-853-2070
Fax 843-853-0044
E-mail sales@arcadiapublishing.com
For customer service and orders:
Toll-Free 1-888-313-2665

Visit us on the Internet at www.arcadiapublishing.com

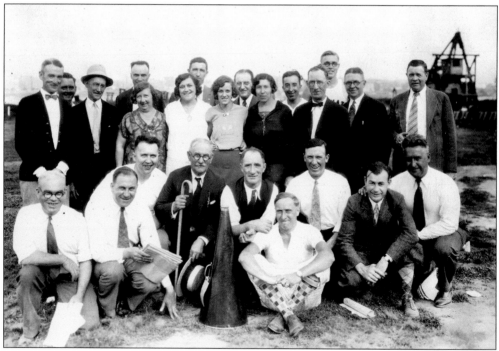

Members of the Field Day Committee pose at the ball field. From left to right are (first row) Thomas James, William Murphy, John Metzger, Mayor John F. Dinan (with cane), Robert Buckley, Charles Pfister, a Mr. Morrisey, John Claes, and former postmaster Fred Oberle; (second row) school superintendent William Conway, Richard Gaul, Harve Maxon, William Walsh, May Brooks, Edith Peterson, Patrick Oates, Sally Kenney, Adolph Lesser, Jessie La Marco, Herman Esser, Michael McDonough, Douglas Pfister, Ed Walsh, and John Quinn. The photograph was taken sometime between 1927 and 1936.

CONTENTS

ACKNOWLEDGMENTS

I wish to thank everyone who helped with this book: first and foremost, my helpmate and partner in life, Lynne M. Grasz, who inspired, encouraged, and assisted me; Edgewater Cultural & Historical Committee member Susan Candee, who asked the Edgewater Colony Association to make its photographs available for the book; Mayor Nancy Merse, who scoured the town and found the longtime residents, including Audrey Tibus, who had historical photographs; fire prevention official Chuck Batch, who made available his private photograph collection; Rusty Stewart of Rusty Kale's, who allowed use of the photographs on his tavern walls; Robert C. Ripley, administrator of the Capitol Commission in Lincoln, Nebraska, who provided photographs of the capitol's tapestries that were loomed in Edgewater; Ruth Paci, neighbor and member of the Edgewater Cultural & Historical Committee, who inspired me to dig into the history of the town and filled me in various aspects of the town's history; Councilwoman Neda Rose, who contributed one of the more interesting and entertaining photographs for the book (page 88), Democrats campaigning with a cart pulled by a donkey and the sign "Harry [Truman] Sent Me"; Al Von Dohln, who provided much material from his personal files; William E. Collins, public affairs director, New York Region, Ford Motor Company, who provided photographs from the Ford archives; Phil Buehler, who took the interior photographs of the abandoned Alcoa plant; Joseph Ferrie, brother of late Mayor John J. Ferrie, who shared his knowledge of the town and times past; Councilman David Jordan, who provided images of the phytosaur and pointed out where the creature was found; Tom Quinton, public works director, who shared his photograph collection and provided a copy of the town seal; Frederick Rotgers of Metuchen, great-grandson of *Borough News* and *Bergen Citizen* publisher Elliott Underwood and great-great-grandson of the founder of those two newspapers, Dr. Benoni Underwood; the Reverend Wanda Lundy of the First Presbyterian Church; Kevin Graver of the Edgewater Cultural & Historical Committee, whose research contributed some important facts; Warren Yeisley of the Wanda Canoe Club; Richard Koszarski, who generously allowed use of material from his book *Fort Lee: The Film Town*; Tom Meyers of the Fort Lee Film Commission, the Fort Lee Historical Society, and the Fort Lee Historic Committee—all of whom supplied photographs; Phyllis Collazo of the *New York Times*, who graciously arranged for use of a generous collection of stories and photographs from newspaper's archives; Maureen Lasher for a rare photograph of Go-Wan-Go; Sylvia Antaramian and numerous other residents who supplied photographs and identified subjects; the authors of three books, for their inspiration—Michael G. Kruglinski (*Shadyside*), Lynn Fox (*A History of the Borough of Edgewater*, 1994), and Ruth Paci (*Down by the River, Under the Cliff*, 1994); and last but not least, Lou Azzollini of Blue Point Graphics, who restored photographs for the book and, at the same time, created Edgewater's first digital collection of its history in photographs.

INTRODUCTION

Edgewater traces the history (including a bit of prehistoric information) of the area that now makes up the borough from its earliest days of settlement through its development as a resort and early days as a fishing village to the industrialization of the area, when companies such as Alcoa Aluminum, Ford Motor Company, Lever Brothers (Unilever), Jack Frost Sugar, and Spencer-Kellogg dominated the small town. These companies are all gone now, and their former waterfront sites are now the location of retail stores, a shopping mall, and upscale townhouses.

The earliest history of Edgewater is from the ages before the dinosaurs. This came to light in an important fossil discovery in 1910.

Although the area that is now Edgewater was first claimed for the Dutch by Henry Hudson and originally settled by David DeVries, a Dutchman, it was a French Huguenot Etienne Bourdett (Burdett) who permanently settled the area after the DeVries community was destroyed by American Indians. It was he who made the greatest effort at colonizing the area, and it was the English who fought to hold on to these colonies during the American Revolution. It was then that the Continental Army retreated from upper Manhattan across the Hudson River to Burdett's Landing, at the northern end of Edgewater, in a retreat that was not reversed until December 25, 1776, when Gen. George Washington led that army from Valley Forge, Pennsylvania, across the Delaware River to the Battle of Trenton.

Washington's army followed a route across the Hudson that had been established in the 1600s with ferry service that connected the area to Manhattan for most of Edgewater's development. Ferry service is about to be restored for the first time in 50 years.

The story of Edgewater traces how the town evolved from a fishing community, to a blue-collar factory community, to a town that traded up to a very different life as it became a bedroom community for commuters to New York and the surrounding area.

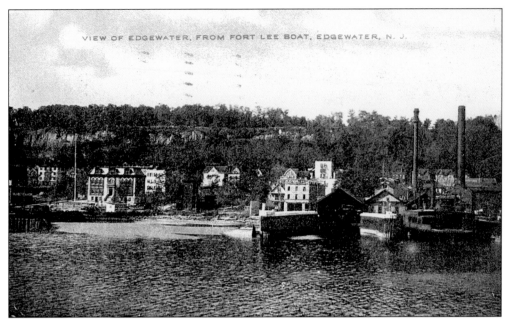

A 1905 view from the Hudson River shows Edgewater as a well-developed industrial town. A point of reference is the prominent borough hall on River Road at Hilliard Avenue (just left of center, with a flagpole next to it). Note how close that building and other structures are to the river. This was before landfill moved River Road from the shoreline of the Hudson to several hundred feet inland. Almost all land east of River Road from Veteran's Field to the Binghamton was filled in the early part of the last century.

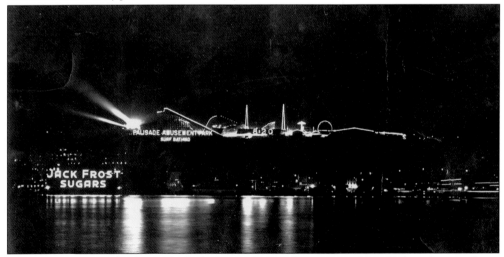

The same view at night shows the Jack Frost refinery advertising to New Yorkers from its River Road factory and the Palisades crowned by the amusement park stretching above Edgewater from Cliffside Park to Fort Lee. Other signs encouraged New Yorkers across the river to use Edgewater-manufactured products. Unilever promoted Spry shortening, and the Corn Products Refining Company put up a 182-foot steel framework with a sign that told the time and promoted products such as Linit and Mazola. As an air-raid precaution, that sign was shut off, a victim of World War II. Later, when the U.S. Navy took over the Corn Products facility, the sign was dismantled and added to a war scrap metal drive.

One

IN THE BEGINNING

Evidence of animal life 220 million years ago in what was to become Edgewater came to light in 1910, when J. E. Hyde, Condit, and Boyle—three Columbia University postgraduate geology students of Prof. James F. Kemp—discovered the major portion of the skeleton of a phytosaur, a crocodile-like reptile of the Triassic period (before dinosaurs). When the first phytosaur was discovered, petrified mud fillings in the jaw were misidentified as herbivore teeth, and thus, the creature was thought to be a plant-eating reptile—hence the name. That could not be further from the truth. The name has stuck, however. A more accurate name, parasuchia, meaning "alongside crocodiles," has been applied but is seldom used. Phytosaurs are not considered dinosaurs but rather semi-aquatic reptiles. Among the most abundant of the fossil reptiles, they are quadrupedal armored carnivores with short legs and a long tail. They grew up to 16 feet in length, and they may have built nests to protect their eggs. Their remains have been found in North America, India, North Africa, and Europe.

Phytosaurs are divided into two subfamilies: Mystriosuchinae and Angistorhininae. The Mystriosuchinae, the type found in Edgewater, are the more primitive and include Mystriosuchus and Parasuchus. They had a very long and slender skull, like the gavials of today, and their snout was tipped with large hook-shaped fangs, with the rest of the jaw lined with uniform razor-sharp, conical teeth—very well adapted for catching fish.

Although the Mystriosuchinea Phytosaur was found in what is now the Edgewater Colony, the town got little credit for the find. The students erroneously reported that they excavated it in the town of Fort Lee, north of Edgewater. When the skeleton was turned over to the American Museum of Natural History, it was named Rutiodon Manhattanensis as if it was from Manhattan.

The first permanent European settler in Edgewater was Etienne Burdett, a Huguenot who had fled to the New World to escape religious persecution in his native France. He first settled in Manhattan and bought several hundred acres of property on the shore of the Hudson River near the southern part of Fort Lee. In 1758, he and his family started a ferry service, which later, in the American Revolution, proved important to the patriot cause prior to and during the Battle of Fort Washington, in 1776. He established a trading post and built his home, a gambrel-roofed structure, at a forest clearing at the foot of a gorge on what is now River Road in Edgewater. This house stood at the site until 1899. From the Colonial period to the present, this particular section of Fort Lee has been known by various names: Fort Lee Park, Pleasant Valley, and Burdett's Landing.

A road connecting the ferry landing to the top of the Palisades later became known as the Hackensack Turnpike. This route is currently known as River Road in Edgewater and as Hudson Terrace in Fort Lee, where it connects with Main Street.

Originally, Burdett's Ferry was used for the transporting of goods and passengers on a type of sailing boat called a periougas. The ferry was one of the major connecting points for the farmers who brought their products from the inland towns of New Jersey to New York City.

During the American Revolution, Peter Burdett (1735–1826), Etienne's bother, was an ardent patriot and operated the ferry for the American army as a supply line and communications network. His wife cooked flapjacks for George Washington and his staff officers when they were in the area of the Burdett ferry and landing prior to the fall of New York, according to grandson T. Fletcher Burdett, a Fort Lee resident in 1900.

Burdett's Ferry had the distinction of being involved in two military engagements during the siege of New York. The first was on August 18, 1776, and the second was on October 27, 1776. Both occasions were against the British ships HMS *Rose* and HMS *Phoenix*, both of which sustained damage.

Burdett's Ferry was pressed into service by the Continental Army to serve as a vital link between Fort Lee and Fort Washington (now the Washington Heights section of Manhattan's upper west side). In the last days before the Battle of Fort Washington, on November 16, 1776, there had been much activity between the forts. There was a meeting between General Washington and his senior officers in the middle of the Hudson River the night before the battle.

The last time the ferry was used during this conflict was to transport Captain Gooch to Fort Washington to deliver a letter from General Washington to Col. Robert Magaw, the commanding officer of the beleaguered fort. Unfortunately, the message was never received due to the heat of battle and the fort being surrounded by the British troops advancing from the south and Hessians from the north. Gooch barely made it back to the boat he used and returned safely to Fort Lee to report the incident to Washington.

A painting, commissioned by King George III (see page 15), shows a landscape and battle scene from midriver looking north up the Hudson (also known in those days as North River), with Burdett's Ferry Landing and the Palisades on the left. Troops are on the landing's dock, and smoke rises from the guns of Fort Constitution (later Fort Lee) and the batteries at the edge of the Palisades (current site of the town of Fort Lee). Upper Manhattan Island, New York City, is on the right, with smoke coming from the guns of Fort Nash, which is flying a red-and-white-striped flag. From the batteries on Jeffrey's Hook below, in the midground in the river, sailing northeast along the Manhattan shore are three British square-riggers, all flying British white ensigns. The names on their sterns are, from left to right, *Tartar*, *Roebuck*, and *Phoenix*. Three smaller vessels off their port side, also flying white ensigns at their sterns, escort them. To their left are two wooden poles sticking up from the water, representing the cheveaux-de-frize (line of defensive obstructions) sunk by the Americans. In the far distance are American row galleys and river craft fleeing ahead on the river.

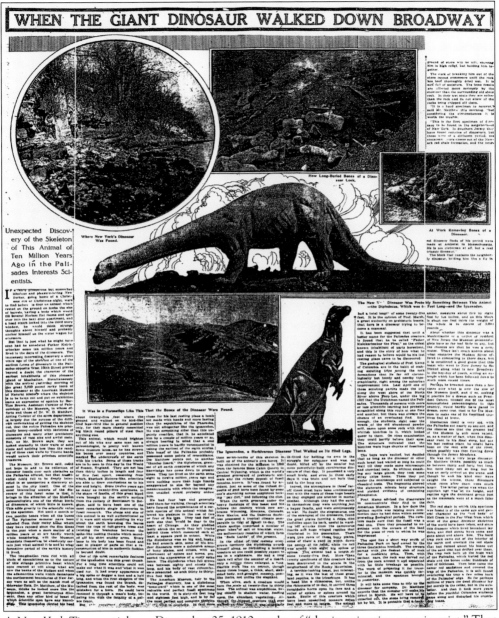

A *New York Times* article on December 25, 1910, spoke of "the imagination running riot." That apparently was going on in the newsroom of the newspaper, as curators of the American Museum of Natural History began studying the bones of a prehistoric phytosaur shortly after they were found on the banks of the Hudson River in Edgewater in what is today the Edgewater Colony. While the phytosaur was estimated to be about 16 feet in length, the *Times* story speculated on giant dinosaurs walking down Broadway looking into third-story windows. The photograph in the circle gives an accurate picture of the site where the bones of a phytosaur were found. But the other illustrations have little to do with the find.

Henry Hudson was the first European to claim what later became Edgewater and its surrounding area (including New York City) in the name of an Old World power, the Dutch. He sailed up the Hudson from September 3 to September 14, 1609, hoping to find a shorter passage to Asia, but he gave up when the river became shallower at what is now Albany. Little is known of his life or any of his voyages before 1607. He must have learned his craft and skills by traveling with contemporary seafarers, probably British mariners, because by the time of his first recorded voyage, he was a captain. His contributions to the exploration of the world as it was then known have generally been understated by modern sources and overshadowed by greater exploits of his contemporaries. No painting or portrait of Hudson painted in his lifetime has ever been found. The oldest ones were painted after his death by people who probably based their work solely on a description.

This is Henry Hudson's ship, the *Half Moon*.

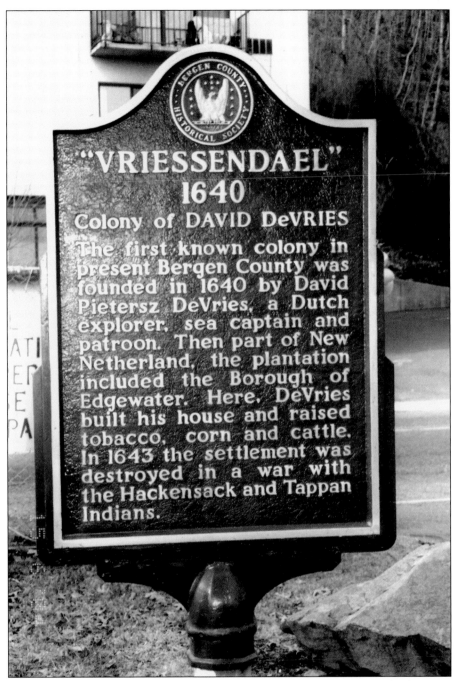

A historical marker in Veterans Field notes the 1640 founding of Vriessendael, the first European settlement in what is now Edgewater and the first such settlement in what is now Bergen County. The marker states, "The first known colony in present Bergen County was founded in 1640 by David Pietersz DeVries, a Dutch explorer, sea captain and patroon. Then part of New Netherland, the plantation included the Borough of Edgewater. Here DeVries built his house and raised tobacco, corn and cattle. In 1643, the settlement was destroyed by the Hackensack and Tappan Indians." After the attack, DeVries returned to Holland.

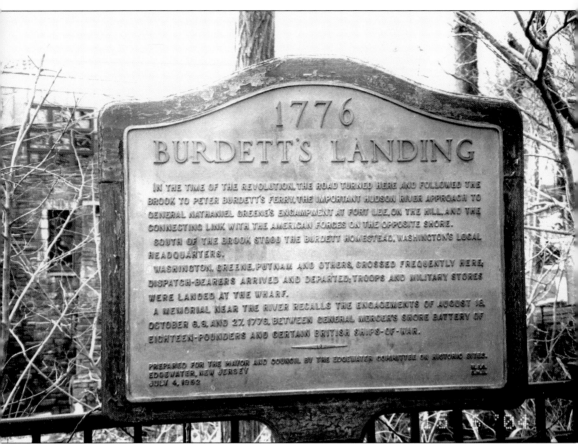

1776
BURDETT'S LANDING

IN THE TIME OF THE REVOLUTION, THE ROAD TURNED HERE AND FOLLOWED THE
BROOK TO PETER BURDETT'S FERRY, THE IMPORTANT HUDSON RIVER APPROACH TO
GENERAL NATHANIEL GREENE'S ENCAMPMENT AT FORT LEE, ON THE HILL, AND THE
CONNECTING LINK WITH THE AMERICAN FORCES ON THE OPPOSITE SHORE.
 SOUTH OF THE BROOK STOOD THE BURDETT HOMESTEAD, WASHINGTON'S LOCAL
HEADQUARTERS.
 WASHINGTON, GREENE, PUTNAM AND OTHERS, CROSSED FREQUENTLY HERE;
DISPATCH-BEARERS ARRIVED AND DEPARTED; TROOPS AND MILITARY STORES
WERE LANDED AT THE WHARF.
 A MEMORIAL NEAR THE RIVER RECALLS THE ENGAGEMENTS OF AUGUST 18,
OCTOBER 6, 9, AND 27, 1776, BETWEEN GENERAL MERCER'S SHORE BATTERY OF
EIGHTEEN-POUNDERS AND CERTAIN BRITISH SHIPS-OF-WAR.

PREPARED FOR THE MAYOR AND COUNCIL BY THE EDGEWATER COMMITTEE ON HISTORIC SITES.
EDGEWATER, NEW JERSEY
JULY 4, 1952

A historic marker in the Edgewater Colony notes the nearby location of Burdett's Landing and
its importance in the Revolutionary War.

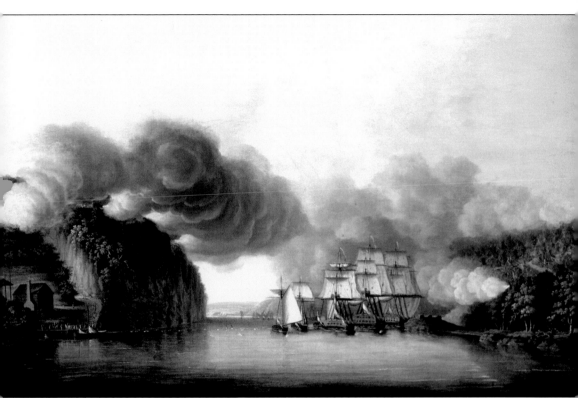

This is a copy of the oil painting *Forcing Hudson River Passage* (1779), by Dominique Serres the Elder, marine painter to King George III. Three copies of this painting were done by Serres for each of the captains of the three major ships in the action, Capt. H. Parker, HMS *Phoenix*; Capt. C. Ommaney, HMS *Tartar*; and Capt. A. Snape Hamond, HMS *Roebuck*. The event depicts the successful British campaign against the American forces of Gen. George Washington, led by Gen. William Howe and his brother, Adm. Richard Howe. The plan was to capture New York City for a base of operation and, later, for an attempt to divide the colonies by securing the Hudson River Valley north to Canada. Royal Navy forces entered New York Bay early in the summer of 1776 and fought a number of skirmishes as far north on the Hudson as Tappan Zee and Haverstraw Bay. The capture of Fort Washington (November 16) and Fort Constitution (Fort Lee) in New Jersey (November 20) ended these campaigns. The George Washington Bridge connecting Fort Lee and New York City today crosses just north of this scene. (Courtesy of U.S. Naval Academy Museum.)

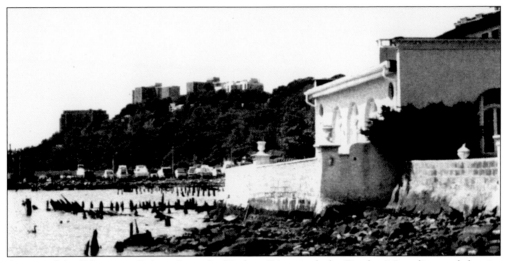

A view of the Edgewater Colony from the Hudson River includes Burdett's Landing and the site where the phytosaur was found.

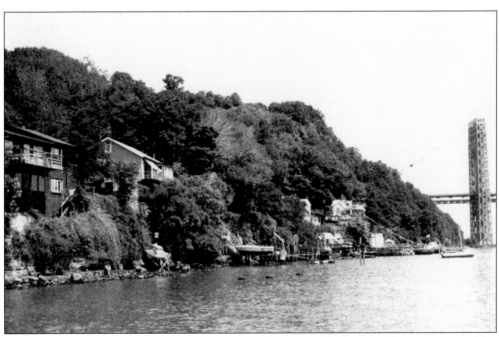

Here is another view of the colony from the Hudson River, looking north. A portion of the George Washington Bridge can be seen to the right.

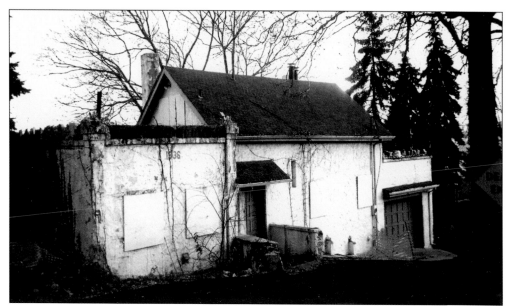

The Edgewater Colony began as a cooperative campgrounds, where members pitched tents in the woods to escape life in the nearby city of New York. Small rents were paid to the Goetchius Estate, which owned the land. When the estate was liquidated in 1947, the 120 residents were given the option of buying the property for $150,000. The following year, 94 residents incorporated to buy the land. By then, tents had given way to simple summer bungalows, which were converted to year-round use. The smallness of the houses gave rise to the rumor that the colony was a community of midgets. These false but persistent tales continue to this day, even though modest summer houses have been replaced by $1 million mansions. If one buys a house in the colony, that is all one acquires. All land of the colony is held cooperatively by the Edgewater Colony Association. This house and the modest one below, located just a few yards away, are two of the older houses in the colony, boarded up and awaiting demolition to make room for larger, grander homes. Note the construction date in the stucco house above: 1936. Although not apparent in this photograph, this house is situated right on the Hudson River.

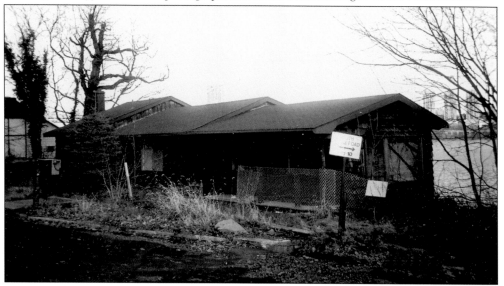

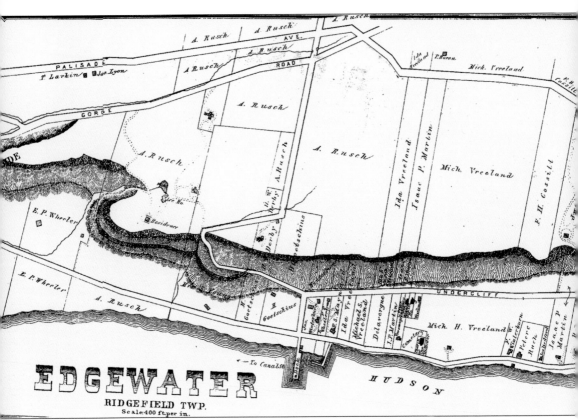

EDGEWATER

RIDGEFIELD TWP.
Scale: 400 ft. per in.

Edgewater is shown before it was incorporated and was part of Ridgefield Township. Pleasant

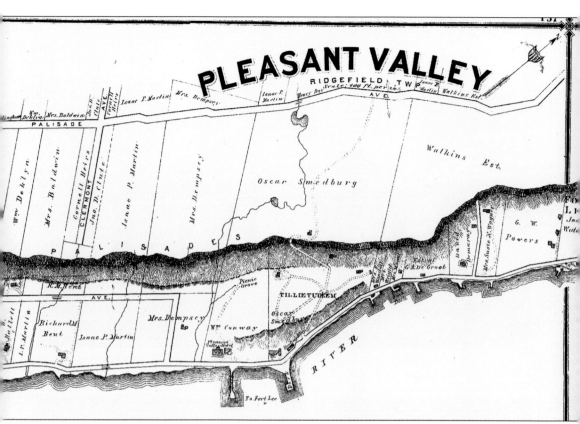

Valley was a name for one section of the town, as were Shadyside and Undercliff.

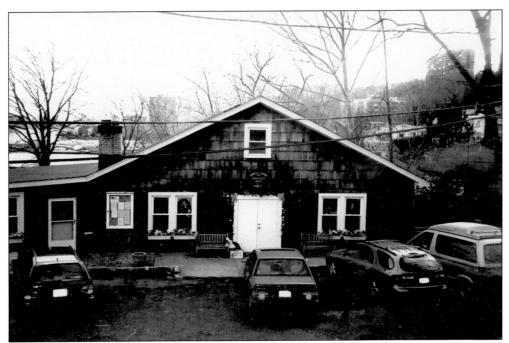

This is the Edgewater Colony Association clubhouse, where members meet to decide policies and to rule on proposed plans for new housing. Social gatherings and parties for Edgewater Colony residents are also held here.

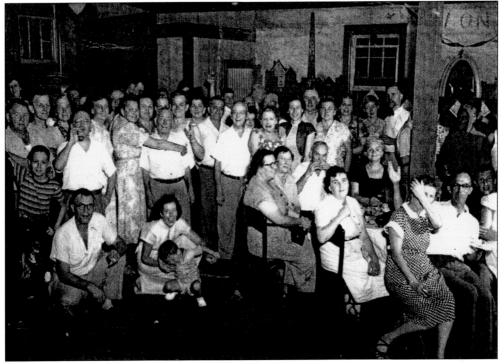

Many large social events have been staged in this clubhouse over the years, such as this New Year's Eve celebration in the 1940s. Note how one woman at the right front seems camera shy.

Two

INDUSTRIALIZATION

The 20th century brought a massive change to Edgewater, as a variety of industry—some of it heavy industry—came to town and soon filled up most of the three-mile shoreline along the Hudson River with piers and large manufacturing facilities. From 1900 to 1930, the population of this tiny town—three miles long and three blocks wide, nestled between the river and the rising Palisades—quadrupled. But the workforce populations, which streamed into and out of the town each day, increased tenfold.

There were plenty of jobs to be had, as the new factories turned out a variety of goods to be shipped to most of the corners of the world. Automobiles were assembled. All sorts of aluminum materials were fabricated into consumer and industrial products. Coffee was roasted. Sugar was refined. All types of oils, from edible products to lubricants, were produced.

What were once the bucolic picnic grounds lost their appeal, and the resort hotels faded. The Edgewater Creche, a country refuge in the late-1880s summers for 5,000 to 10,000 mothers and children from New York City tenements, found Edgewater no longer suitable and moved north to Englewood.

The town got tougher and a bit rougher with industrial might. It even got a new industrial heart at Alcoa, with an impact press, which pounded around the clock, seven days a week, as warm aluminum, fresh from what was then the second largest rolling mill in the nation, was pounded by brute strength into useful products at what Alcoa called its Edgewater Works.

The Edgewater Works served Alcoa well through a boom time in aluminum, as use of the metal expanded during two world wars and peacetime. During World War II, fabrication of parts for air force fighters and bombers were a principal product. During the 1920s, aluminum use was expanded for all sorts of household products and appliances. The plant began making small collapsible tubes in 1921, principally for use as toothpaste containers. By 1922, some 70 percent of production was allocated for making aluminum parts for Hoover vacuum cleaners. Another major product was bearing caps for Packard automobiles.

Eventually, the success and growth of aluminum doomed the Edgewater Works. It was too small, and there was no room to expand, especially the rolling mill. Alcoa had outgrown Edgewater. The plant was closed in 1967. It stood empty for more than 20 years before it was demolished to make way for a low-rise apartment complex, Avalon at Edgewater.

As in other industrial sites around the country, the first half of the 20th century saw the struggles of union organization, with violence and some murder. The town became gritty and grimy with smoke and soot and pollution—all left for subsequent generations to clean up. Industrialization was spurred by a hole that was punched through the Palisades, permitting coal-fired steam trains belching cinders and sparks to chug through the Susquehanna tunnel from

Fairview to Edgewater and up and down River Road—the nearest thing to a main street that the little town had—bringing coal to fire the factories and hauling away freshly manufactured goods that were not otherwise loaded on ships at the Edgewater piers. Some of the coal was taken across the Hudson River to Manhattan to provide power, heat, and light to New York City.

The docks where this coal was stored became the scene of murder and mayhem on December 11, 1912, when 200 strikers clashed with 130 strikebreakers, who were brought to Edgewater by the ferry *Edgewater*. Some of the strikers responded to the intruders by brandishing a variety of firearms. Soon, two police guards lay dead in a hail of bullets and buckshot. Local police were no match for this, and Mayor John Clahan Jr. contacted Sheriff Robert Conklin in Hackensack, who, by nightfall, swore in a posse of 50 deputies to begin the hunt for the killers. With rumors that some of the strikers planned to dynamite the railroad tunnel, Deputy Sheriff Robert Heath sent guards to the railroad property. Scores of police and strikebreakers were injured, with the most serious taken to Hackensack and Jersey City hospitals. Others were treated at the borough hall. In the end, 10 strikers were arrested, indicted, and brought to trial. Five—Antonio Ferraro, Mariano de Lucia, Constantino and Antonio Celia, and Antonio Mancini—were convicted of second-degree murder.

Although much remediation has been done in Edgewater, as the brown fields of abandoned industrial sites have been converted into the green fields of living space for town houses, one unhealed sore remains on the waterfront landscape: the Quanta Superfund site.

For 78 years, coal tar, used as a roofing material and in products for road paving, was produced at the site. Beginning in 1974, recycling of waste oil was conducted here. Quanta Resources Corporation leased the site on July 15, 1980, and conducted storage, reprocessing, reclamation, and recovery of waste oil. As a result of this operation's poor housekeeping, improper disposal practices, recurring spills, discharges, flooding, and rainwater overflows at the site, on-site soils, sediment, and groundwater were contaminated with tar materials and oils containing hazardous substances, according to a public health assessment by the New Jersey Department of Environmental Assessment.

Quanta Resources filed for bankruptcy on October 6, 1981. Under the Comprehensive Environmental Response, Compensation and Liability Act of 1980, the U.S. Environmental Protection Agency assumed the lead responsibility for the control of the site; the site was proposed to be added to the National Priorities List of Superfund sites on January 11, 2001.

Significant remediation has been conducted on the site, which once had 61 aboveground storage tanks with a total capacity of approximately nine million gallons, about 10 underground storage tanks with an estimated capacity of 40,000 gallons, and numerous underground transfer lines and pipes. These tanks were used to store coal tar, oil, tar, asphalt, sludge, process water, and other liquids. Many of the aboveground tanks had wooden roofs that were partially or totally collapsed, allowing rainwater to enter and overflow. About 50 drums containing oils, sludge, contaminated absorbent materials, debris, and uncharacterized materials were staged on the site.

On July 2, 1981, the New Jersey Department of Environmental Protection stopped all oil-recycling activities at the Quanta Resources site when it was discovered that the storage tanks contained nearly 266,000 gallons of waste oil contaminated with polychlorinated biphenyls (PCBs) in excess of five times the 50-parts-per-million limit set forth by the federal Toxic Substances Control Act.

Industry had its artistic side as well in Edgewater. The Edgewater Tapestry Looms became renowned for quality large tapestries by the 1920s. According to *The Practical Book of Tapestries* (1925), by George Leland Hunter, the "Edgewater factory has been most successful in weaving for the trade and developing texture that without having all the refinements of ancient Gothic texture, avoids the board-like surface of many modern tapestries."

And what could have been more artistic than the movie business. When Fort Lee was giving birth to the movie industry, much of the cinematic activity spilled over into surrounding towns. Edgewater was not just a back lot for Fort Lee. There were actual studios located in Edgewater,

but much of what they produced seems to have been lost to history. Much like the early silver nitrate film, it has turned to dust.

Little is known today of such Edgewater studios as the Momus Company or Good Luck Film Company. Momus seems to be best remembered for its production of a short film promoting the need for updated firefighting equipment at the request of Mayor Henry Wissel and Thomas Trolson, chairman of the borough council's finance committee.

On May 16, 1915, the *New York Times* reported that Momus produced its first comedy, *Doctor Cupid*, which had a scenario developed by Walter Morton, one of the managers of the concern.

Moving Picture World on June 15, 1915, reported that M. A. Neff, former national president of the Exhibitors League of America, had entered the ranks of producers as general manager of the Good Luck Film Company, which was making its first picture at the Century Studio in Edgewater. The film, *The Battle of Ballots*, was released in August 1915. It starred Mayre Hall and William Wells and had a story line that promoted the virtue of Prohibition. Little else is known of Good Luck, except a company by that name is mentioned in a 1924 article in the *New York Times* as having been located in Cuba. This may be a totally different company.

The only other report of an early film being made in Edgewater was the epic *The Siege of Quebec*, which is remembered for a riot by hundreds of extras during the filming over how much these extras were to receive for lunch pay.

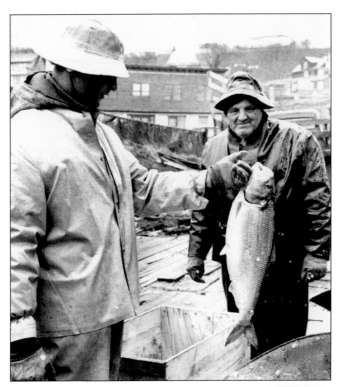

The first industry of Edgewater was one that went back through the 19th century and beyond. Fish were taken out of the Hudson River long before it was polluted and its riverbed was lined with cancer-causing PCBs. An annual spring ritual was the work of the shad fishermen, who would set out nets to catch the shad in their run from the Atlantic Ocean up the Hudson to spawn. The hauls were big in the old days and included the females carrying the prized shad roe. Shad fisherman William "Pops" Ingold, in a 1950s or early-1960s photograph, admires a prized catch displayed by his son Ronnie. A good season in those years could produce a catch of a million pounds.

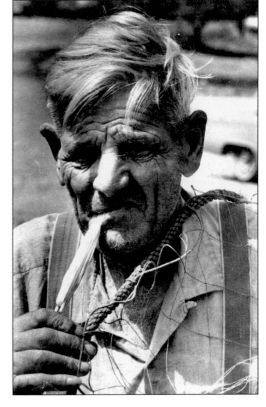

The successful shad fisherman kept his nets in good condition. William Ingold, in this close-up, uses his hands and his teeth to make repairs to one of his nets. One of the leaders of this industry was George Kotze, who died at the age of 47 on April 19, 1947. Kotze owned one of the largest shad-fishing camps along the Hudson River, employing 50 to 100 fishermen during the spring season. He was an acknowledged expert, not only in catching the fish but also in preparing them. In 1935, he established a catering business at his inn, the Colonial Grill, which was near his home at 1234 River Road. He was founder and president of the Hudson River Shad Fishermen's Association.

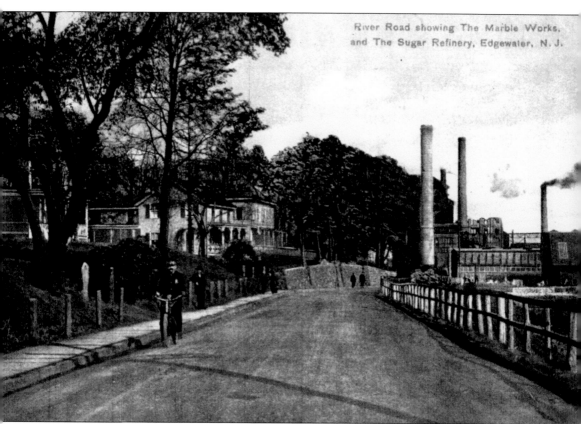

River Road showing The Marble Works, and The Sugar Refinery, Edgewater, N. J.

Before the factories came, there was another early industry in Edgewater, one that threatened a natural wonder that defined the western boundary of the town, the magnificent Palisades. Russell & Read made paving blocks to fill the demand for cobblestones, a popular pavement for streets in the 19th century. It is said that stones cut from the New Jersey Palisades paved many of the streets in New York City, including Broadway. Burdett's Landing, of Revolutionary War fame, became the Old Stone Dock, where lighters pulled up to haul the stones across the Hudson to Manhattan. In the early years, as industry began to settle along the waterfront of Edgewater, the town for a time continued to maintain its bucolic character. Consider this all but desolate River Road, as a cyclist travels along just below the marble works and the sugar refinery. The refinery changed hands several times and grew much larger before it burned down and relocated elsewhere.

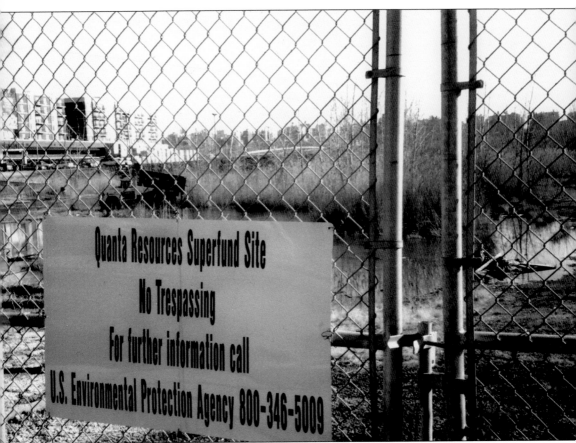

One of the oldest industrial sites in Edgewater is today a 16-acre Superfund site awaiting cleanup. Its industrial use began in 1896, when the Barrett Manufacturing Company began coal tar distillation. On the evening of July 17, 1928, the Barrett plant was the scene of a spectacular fire that lit up the night sky and, as a result, tied up traffic on Manhattan's West Side Highway, as motorists stopped to view the fire and the thick black clouds that rolled east across the Hudson River. The fire started with the explosion of a heater in the plant that manufactured Tarvia, a preparation for surfacing highways. Four years earlier, on June 7, 1924, some 10,000 gallons of pitch burned at this site after a tank holding this material leaked and caught fire. Today, this land at 163 River Road is known as the Quanta Resources property, named after the last operation on the site, the Quanta Resources Corporation. Other industries in Edgewater, with roots in the 19th century, included Valvoline Oil (petroleum products, 1873), Corn Products (edible oils, 1896), and James Pyle & Company (soap and wash powders, including the brands Pearline soap, OK Naphtha Washing Powder, and Soapade). James Pyle & Company moved from Manhattan to the Edgewater riverfront in 1904. Seven years later, its goodwill and trademarks were sold to Proctor & Gamble.

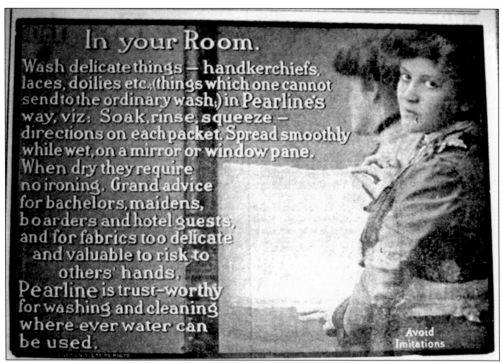

Shown here is an advertisement for Pearline soap.

Samuel Bryant was the secretary-treasurer of James Pyle & Company.

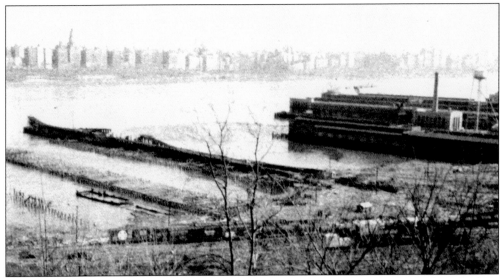

Coal was the king of industry in the first half of the 20th century, and much of it was brought from the mines of Pennsylvania and Appalachia by rail to Edgewater, not only for the furnaces of local industry but also as a transfer point to barges to take this fuel to fill the needs of New York City. Shown here are the Edgewater coal docks of the New York, Susquehanna & Western. During the industrial period in Edgewater, there were numerous labor disputes and strikes and some violence, but none was as bloody as the coal dock strike of 1912, when two police guards died and mob violence for a time prevailed. The heart of Edgewater's industry belonged to Alcoa, the Aluminum Company of America, which came to the tiny town in 1914, when it was alternately known as the American Aluminum Company or the U.S. Aluminum Company.

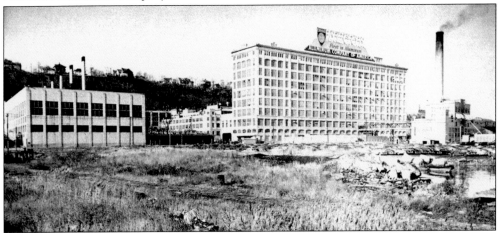

The Alcoa facility consisted of two main buildings: the rolling mill (left), which when it was constructed in 1937 at a cost of $3 million was the second largest aluminum rolling mill in the world, and the main factory with offices, which before its demolition was on the National Register as an early example of a larger factory built with poured concrete. Sandwiched between these two buildings is the Edgewater Cemetery, created by the Vreeland family as a private cemetery. It was later associated with the Episcopal Church of the Mediator, and when the church disbanded, it became a town cemetery, which it is today. To the left of the cemetery is the Alcoa rolling mill, which is still standing, awaiting a new use. Several feet have already been removed from the rear of this building to create a small neighborhood park.

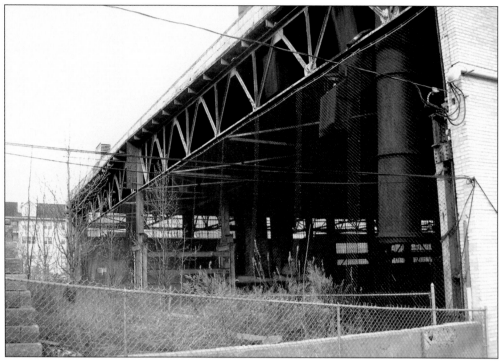

This photograph of the rear of the rolling mill shows how the back of the building was cut away a few years ago to make room for a neighborhood park.

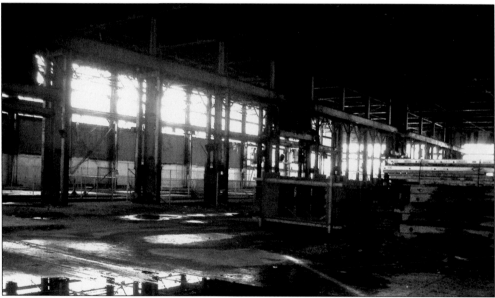

The furnaces are long stilled, and the interior of the rolling mill has long been in many years of darkness. But this photograph, taken through an opening in the side of the building, shows the work area where six-and-a-half-foot aluminum ingots were heated and rolled under pressure until some were a tenth of the thickness of a newspaper and stretched for 45 miles in large rolls of the metal. Some of these sheets were fabricated in the nearby factory, and others were shipped to customers for further processing.

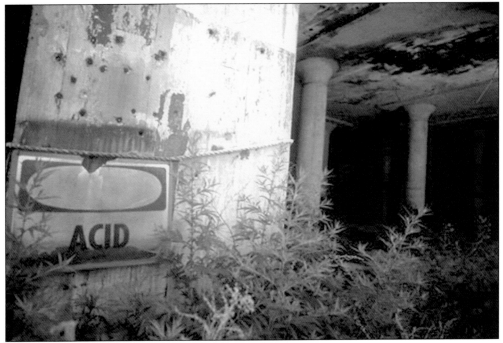

With sections of the roof removed and the windows out, weeds grow in the abandoned building where once there was the danger of acid. This, and the following few photographs, were taken shortly before the main Alcoa building was razed by Phil Buehler. There were once plans to convert the old factory into apartments, but the remediation costs were prohibitive.

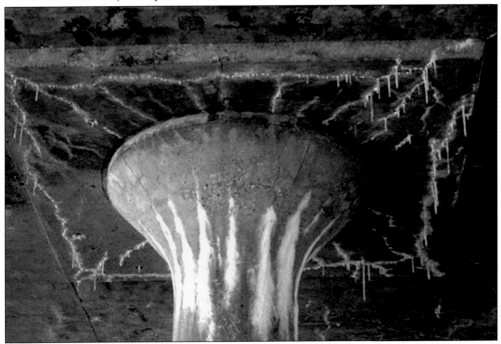

An interior concrete column of the old plant has its own kind of growth. Chemicals seeping through the concrete form a design on the column as small stalactites drip from the ceiling.

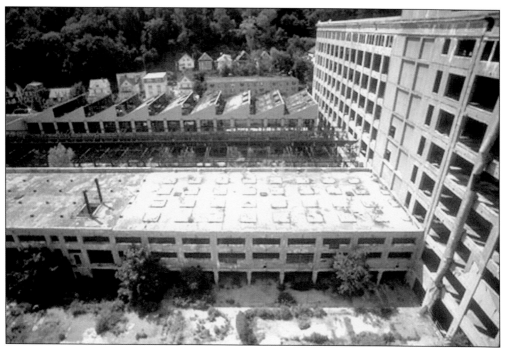

This photograph was taken from the roof of the main Alcoa building, looking down on a complex of smaller buildings.

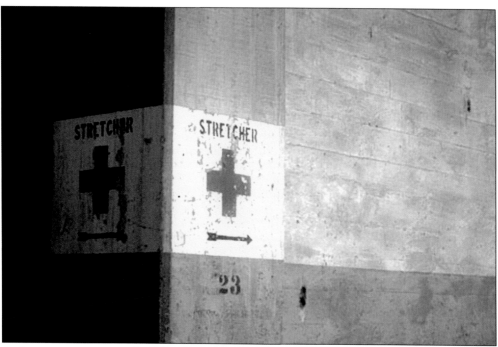

A sign on an interior wall of the Alcoa building points the way to a long-gone first-aid station equipped with a stretcher.

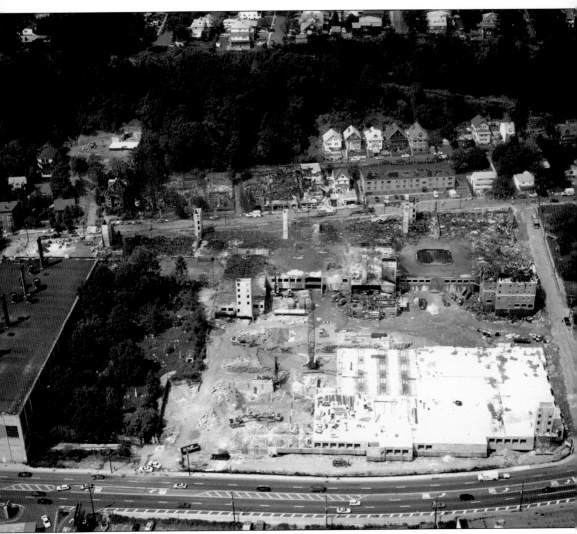

The main Edgewater plant was razed for the construction of an Avalon low-rise apartment complex. But while the Avalon project was under construction, a fire swept through the unfinished buildings, destroying most of them as well as several houses across the street on Undercliff Avenue. This aerial view of the site shows the Avalon destruction as well as the burned-out shells of those houses. No one died or was injured in the fire, but numerous families were left homeless, and many of them left town. One of the houses that burned was the scene of a notorious murder in 1921 (see page 116). This aerial photograph also shows the Edgewater Cemetery (an area with trees on the left) and the Alcoa rolling mill (farther to the left).

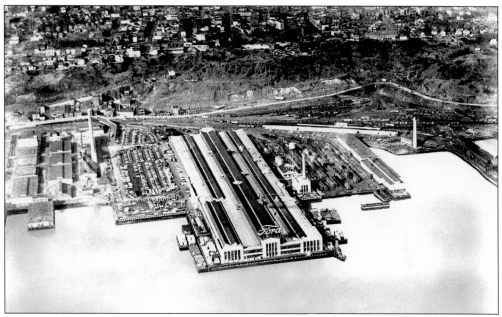

These aerial views show the Ford assembly plant, now the site of Independence Harbor condominiums. The 400,000-square-foot plant was built after Ford took title to the 35-acre riverfront tract in July 1929. At its peak, 4,000 workers were employed at this facility. The building was designed by Albert Kahn, who became known as the architect for "the car guys" after he modernized the industry's assembly plant concepts for Packard Motor Car Company shortly after he opened his architectural offices in 1895.

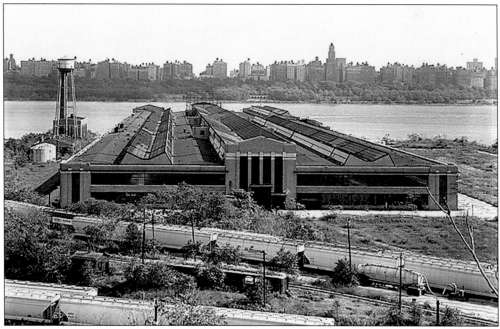

This view of the Ford assembly plant, looking across the Hudson River and toward Manhattan, shows the rail lines serving the plant.

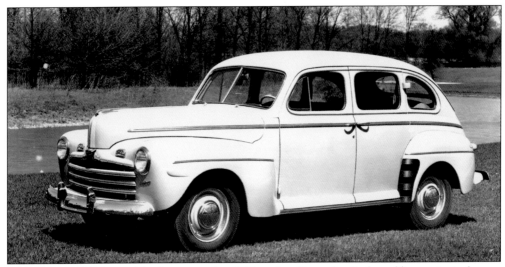

The Edgewater Ford assembly plant opened in 1930, and on December 8, the public was invited to see cars assembled in 48 minutes on the 1,500-foot-long facility constructed on a pier. The cars were Model A Fords. New models were brought out each year beginning in 1932. At the start of World War II, production was shifted to military vehicles, Ford Jeeps and light trucks. Jeep production began in 1943. During these years, the plant produced 130,000 military vehicles, with many of them shipped to Russia. Production of civilian cars was resumed on August 13, 1945, with the 1946 Ford, seen here. When production resumed, air ace Capt. E. V. Rickenbacker and movie actress Carole Lewis were on hand for the event. Production began at 15 cars a day, with an increase after a few weeks to 50 cars a day. Before Pearl Harbor, the peacetime production was 400 cars a day. Executive vice president Henry Ford II had said in 1944 that the company hoped to price the new Fords at less than $800.

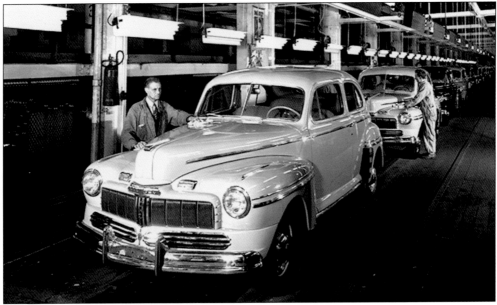

Beginning in November 1938, Ford added the medium-priced Mercury to its line of cars in production at Edgewater. When production of the Mercury began, Edgewater was building 7,000 vehicles a month, and 2,100 of these were Mercurys. Production of the Mercury resumed in 1945 after World War II with the 1946 model shown here coming off the assembly line in Edgewater.

Edgewater Ford's new plant manager succeeded C. A. Easlinger, who had overseen the facility since 1932.

W. K. Edmunds

W. K. ~~Edmunds, who~~ for eight years has been in charge of Ford activities in Chicago, has been named manager of the branch in Edgewater, N. J., it was announced yesterday. Mr. Edmunds joined the Ford company in Memphis in 1913.

H. C. Doss, former manager of the Kansas City Ford branch, succeeds Mr. Edmunds at Chicago. C. A. Esslinger, for the past six years manager at Edgewater, is now manager at Chester, Pa.

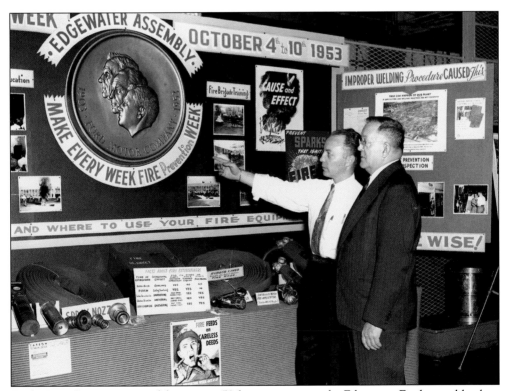

Ford Motor Company was celebrating its 50th anniversary at the Edgewater Ford assembly plant when fire safety was being stressed during Fire Prevention Week in 1953. A year later, the plant closed. The man on the right with glasses is fire chief George Lasher. The emblem in the center of the display shows the profiles of Henry Ford, Edsel Ford, and Henry Ford II. Many serious fires struck Edgewater during its industrial age, but none of them occurred at Ford.

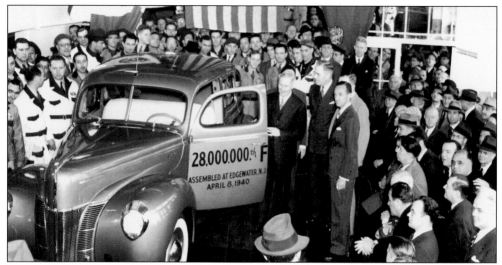

Before the Edgewater Ford plant was closed on July 15, 1955, the plant's final and 1,817,938th Ford rolled off the line. Production was shifted to a new and larger plant in Mahwah, which has since been closed. It was a big celebration on April 9, 1940, when the 28 millionth Ford (combined production for all plants) rolled off the assembly line in Edgewater. Standing next to the open door are New Jersey governor A. Harry Moore, Wallace R. Campbell (president of Ford Motor Company of Canada), and Edsel Ford (president of Ford and son of the company's founder, Henry Ford). After the Edgewater ceremonies, this special gray four-door sedan was driven to the "Road of Tomorrow" at the Ford Exposition at the New York World's Fair. It then went on a tour of the United States, Mexico, and Canada. Ford sold the Edgewater plant in 1961, and the title was passed to New York reality investor Irving Maidman and banker K. B. Weisman. The property was redeveloped for shipping and industrial uses. Eventually, the old plant was abandoned, and it crumbled. The pier and surrounding land was developed into an apartment complex known as Independence Harbor.

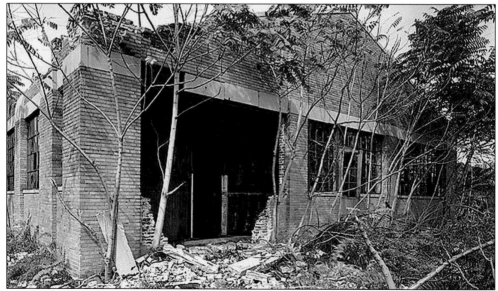

This view shows the oil house at the Ford assembly plant property after the plant was closed in 1955.

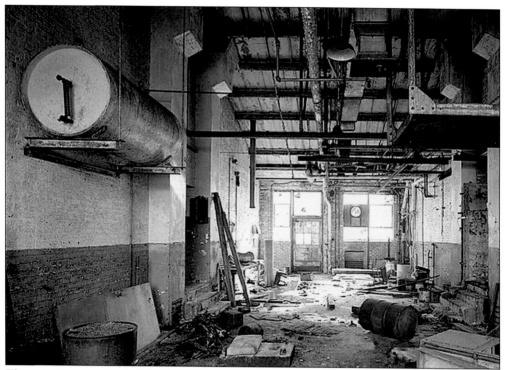

This is an interior view of the oil house at the Ford plant site after it was closed.

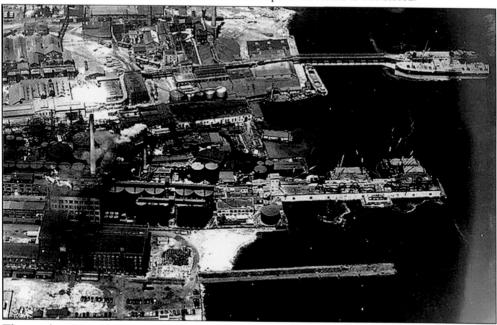

The production and processing of oil was a major industry in Edgewater, from edible oils to a variety of oil used for industry. One of the largest producers of this industry in Edgewater was Spencer Kellogg, with local facilities that included the largest linseed oil production plant in the world. That and its various buildings and storage tanks are shown in the center of this aerial photograph.

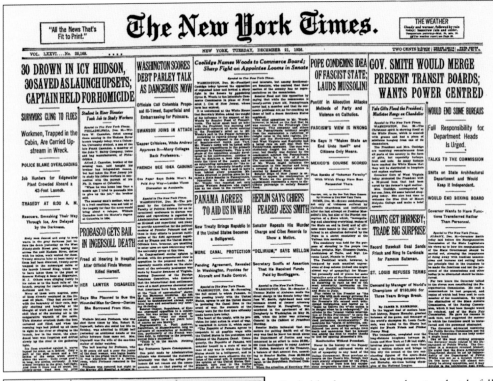

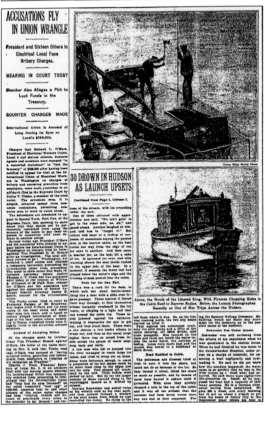

Probably the greatest calamity that befell Spencer Kellogg, certainly the one that took the greatest toll of life, occurred on December 20, 1926. Spencer Kellogg drew many of its workers from Harlem, just across the Hudson River from Edgewater. To get these workers to their jobs in New Jersey, Spencer Kellogg operated its own 42-foot motor launch, the *Linseed King*, built in 1923. This seemed like a good arrangement until disaster struck. The *New York Times* pages tell the story. Litigation over the sinking of the launch dragged through the courts for years, finally reaching the U.S. Supreme Court, which ruled on April 11, 1932, that Spencer Kellogg could not limit its liability, and lawyers representing families of men who drowned or were injured were not restricted by the limitations of compensation stated in the New Jersey Workman's Compensation Act. This basically left standing the $124,000 won in awards by the families of 18 men who drowned and another 12 who were injured in the disaster.

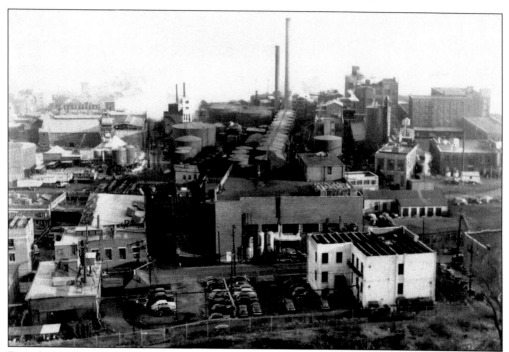

By today's safety standards, the industry that came to dominate the town by the 1930s and 1940s would seem downright dangerous. Companies at that time made and used a variety of noxious, volatile, and dangerous chemicals and materials. One construction company stored dynamite in earthen bunkers. This 1941 photograph shows three major manufacturers sandwiched tightly together in the southern end of town: to the left of center, Barrett (coal tar); in the center, Spencer Kellogg (linseed and other oils); beyond the white building in the foreground, Fasey & Besthoff (ammonium nitrate).

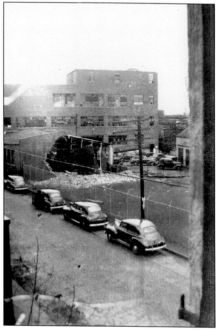

The damage from a hydrogen explosion at the Spencer Kellogg facilities on Sunday, December 14, 1941, is illustrated in this photograph and in those on the following page. The explosion, which killed one worker, occurred just one week after the December 7 bombing of Pearl Harbor, and some nearby residents were sure the Axis powers had struck again. This photograph was taken from a window of a nearby apartment building. Some 15 months later, on March 18, 1943, a two-story hydrogen-storage tank blew up at the plant, sending a sheet of blue flame seven stories high.

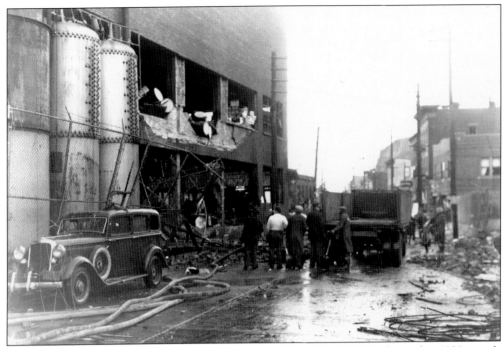

A photograph taken from another angle shows a luxury automobile from the 1930s, with whitewall side spare-tire mounts, which seems to have escaped the blast.

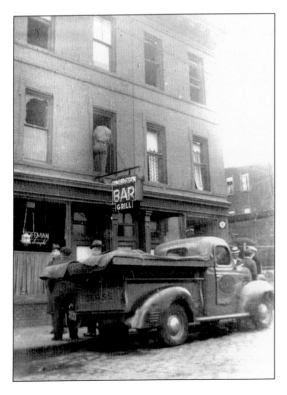

The explosion knocked out windows in several buildings in nearby Shadyside. Here, a glazier begins to make repairs to a window in an apartment over the American Bar and Grill.

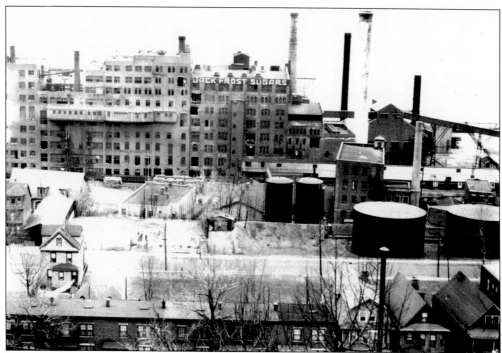

Industrial fires were frequent in Edgewater, and many plagued the sugar refinery. The refinery began operations in 1902 as Knickerbocker Sugar. It became Empire Sugar in 1904 and was Warner Sugar in the year following that. Finally, in 1927, the operation was acquired by National Sugar, which marketed the product as Jack Frost sugar. This photograph not only shows most of the Jack Frost sugar refinery on River Road but also displays a time when Edgewater Place (road in the center) was partly industrialized with homes competing for space with oil tanks. In the near foreground are houses on the east side of Undercliff Avenue.

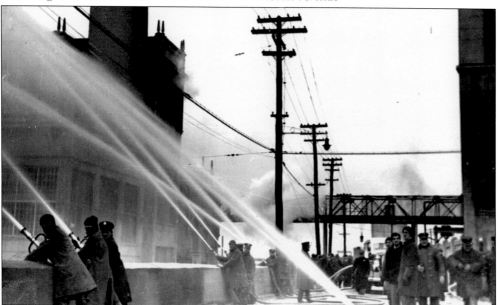

Firemen are well prepared to douse this blaze at the sugar mill.

In 1928, Jack Frost Sugar was introducing new products that are no longer around today.

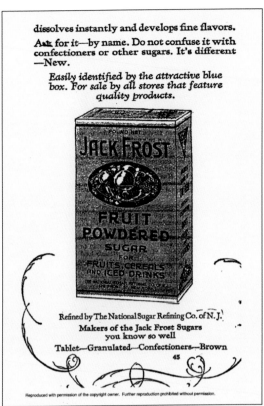

dissolves instantly and develops fine flavors.

Ask for it—by name. Do not confuse it with confectioners or other sugars. It's different —New.

Easily identified by the attractive blue box. For sale by all stores that feature quality products.

Refined by The National Sugar Refining Co. of N. J.
Makers of the Jack Frost Sugars you know so well
Tablet—Granulated—Confectioners—Brown

45

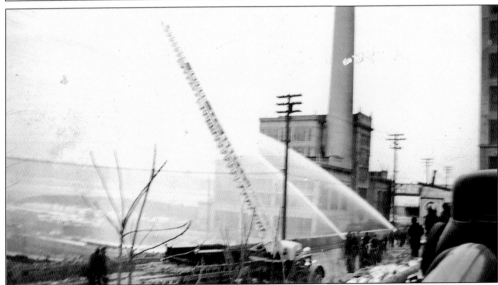

The last fire at the sugar mill was in 1954, some 10 years after Jack Frost had abandoned the building due to lack of sugar during World War II. The building was stripped of its machinery in 1944 and sold at auction for $25,000. The aging building all but burned to the ground. Jack Frost sugar is today refined and packaged in Yonkers, New York. One small building of the Jack Frost complex remains in Edgewater today. Located on the west side of River Road, it was converted into apartments for residential use several years ago.

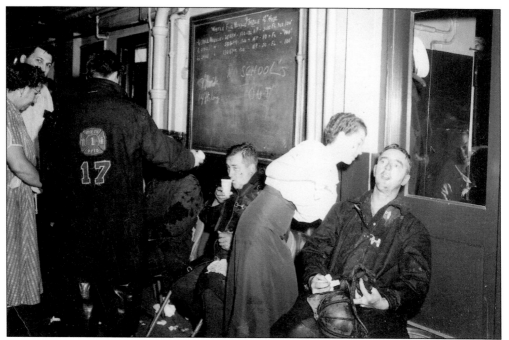

Firemen take a break from the sugar mill fire at the firehouse in borough hall. At the right is fireman Clem Coleman.

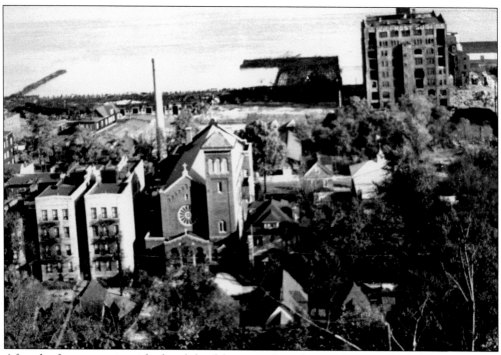

After the fire was extinguished and the debris was cleared away, there was little left of the sugar house except a smokestack and one building of what had been a large complex. That building is at the right near the river. In the foreground is the Church of the Holy Rosary on Undercliff Avenue and two apartment houses to the left of the church.

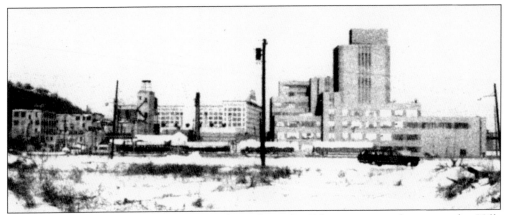

Another factory that had a prominent place along the Edgewater waterfront was the Hills Brothers coffee plant, which was built in 1940 on a 15-acre tract. The plant included a 14-story mixing tower, which rose to a height of nearly 200 feet. Facilities included a 620-foot conveyor shed to bring green coffee beans from plantations from various parts of the world into the plant from its own pier. There was also 700 feet of railroad siding inside a train shed. The plant has since ceased production and all has been razed.

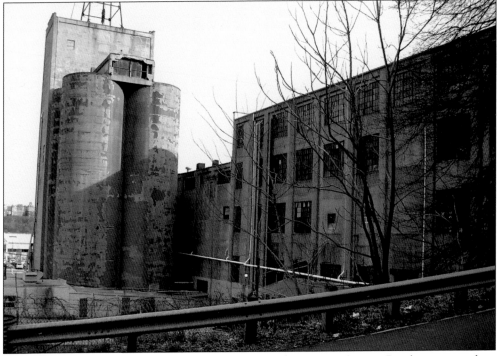

This chemical factory on the south corner of Archer Terrace and River Road was erected on the site of the home of Mayor Henry Wissel, who sold the site to Archer Daniels Midland Corporation. Henry Wissel then built a new home on Hilliard Avenue and Undercliff Avenue. Over the years through various occupants, the factory has produced a variety of chemicals, many of which are considered hazardous. Most recently, Octagon Processing manufactured deicing fluid for the aviation industry. Redevelopment plans for the site, which have been approved by the borough, call for demolition of the factory and, after pollution remediation, construction of a high-rise apartment building.

There is a more artistic side to the industries that have operated in Edgewater. Lorentz Kleiser opened the Edgewater Tapestry Looms in 1909, not in the industrial southern end of town but in the north, where the better houses frequently inhabited by local factory managers could be found.

The tapestries won wide respect and were in demand until the looms ceased operations in the 1930s during the Depression. But in its heyday during the 1920s, the plant was producing the only hand-woven tapestries in the United States. After the looms closed, the buildings became the home of the Wyckoff School of Stage and Art Crafts, where marionette making, stage design, and costuming were taught. The school was associated with the Ogunquit Playhouse in Ogunquit, Maine. This location now houses four condominiums, which are little changed on the exterior of the buildings.

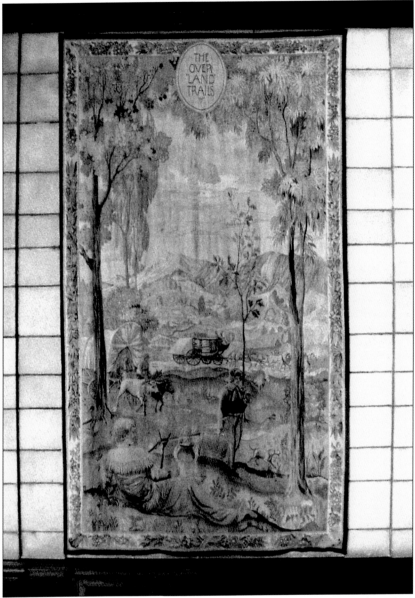

Today, three of these tapestries hang in the Nebraska state capitol in Lincoln. The Missouri state capitol in Jefferson City has 11 tapestries on display. Others grace the U.S. Senate Lounge in Washington, D.C.; one is reportedly held by the Newark Museum. Shown here is one of the custom-designed tapestries in the supreme court chamber of the Nebraska state capitol. It portrays the overland trails that settlers followed to the West. Inscribed on the back of the tapestry is the following: "During the Civil War, the great industry of the period in Nebraska was transport by the Overland Trail routes from Kansas City, St. Joseph, Leavenworth, Atchison, Nebraska City and Omaha converged at Ft. Kearney on the Platte River. Freight carried over these trails amounted to 200,000 tons in 1865. The trail transportation business terminated with the construction of the Union Pacific Railway in 1865-67. An original design by Lorentz Kleiser, cartooned and woven by hand under his direction by the Edgewater Tapestry Looms with vegetable dyed materials."

A close-up of a section of the fabric mural shows the detail of the hand weaving.

LORENTZ KLEISER, MADE TAPESTRIES

Painter and Designer Dies —Led Edgewater Looms

EAST CHATHAM, N. Y., May 29 (UPI)—Lorentz Kleiser, internationally known artist and designer of hand-loomed tapestries, died yesterday in his home in nearby Redrock. His age was 84.

In 1913, Mr. Kleiser founded Edgewater Tapestry Looms, Inc., designing tapestries that now hang in permanent collections in museums across the country. His designs won the Frank G. Logan Medal of the Chicago Art Institute.

Lorentz Kleiser died on May 29, 1963. This dispatch from United Press International was carried in the *New York Times*.

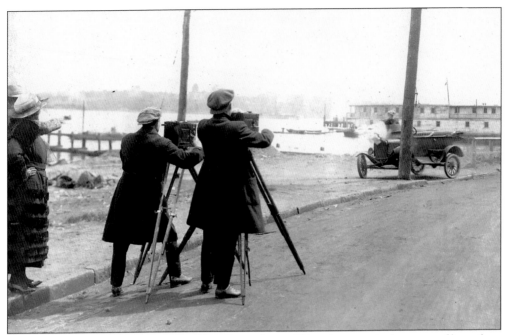

Little evidence remains of the Edgewater film industry. This photograph shows two filmmakers cranking their cameras to catch the action of a staged car crash in a film in production on River Road in Edgewater in 1918. There is no information on whether this scene was used in a completed film or what film that might be.

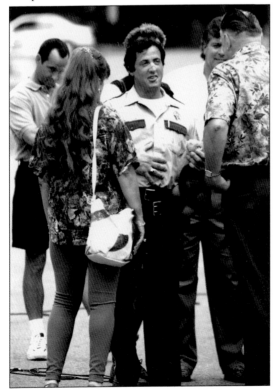

In 1997, the film *Cop Land* was made in Edgewater. Starring Sylvester Stallone, Harvey Keitel, Ray Liotta, Robert De Niro, and Janeane Garofalo, it used extensive interior and exteriors in Edgewater. Sylvester Stallone gained 40 pounds to play the role of Sheriff Freddy Heflin. Here, he takes a break to chat with some of the residents. At the right is retired boxer Chuck Wepner of Hoboken, who no doubt had some conversation with Stallone about a film character Stallone portrayed, Rocky.

Three

EDGEWATER, THE TOWN ITSELF

Overwhelmed for much of its history by industry that took over much of the four-tenths of a square mile of the town's geography, Edgewater has never had much of a core or typical Main Street that can be found in most towns, and certainly towns as old as Edgewater (incorporated in 1894). The nearest thing to a main street is River Road, which during the industrial era had railroad trains running up and down the center of it, dropping off and picking up materials from the various factories.

Today, River Road is four-lane thoroughfare that some complain is too much like a highway. It provides a connection between the George Washington Bridge in Fort Lee and the Lincoln Tunnel in Weehawken. Practically all of the shops in Edgewater that were constructed in the last few years are either in strip malls or urban settings. A focal point once existed at River Road and Dempsey Avenue, where the 125th Street ferry met trolley cars that would go up the Palisades to Cliffside Park and points west.

When the George Washington Bridge was completed in 1931, motorists found it more convenient to drive across the bridge in Fort Lee for excursions into New York City, Long Island, or New England. The ferries stopped running in 1955, unable to compete with the popularity of the automobile that had the mobility to cross the Hudson River by bridge or tunnel.

This chapter also covers the servicemen from Edgewater who fought in four of the nation's wars. Edgewater lost 31 residents in three wars. The following are listed on a monument in Memorial Park as having given their life for their country: (World War I) J. P. Farrell, M. Murphy, W. Regan, G. H. Weir, and A. Zaikowski; (World War II) Paul O. Allen, William E. Barber, William J. Conway, John J. Delaney, John F. Eager, Jake J. Englander, Robert M. English, William S. Ford, Benjamin L. Godleski, Alonzo H. Greenlaw, Ronald F. Greer Jr., Frank E. Huber, Edward W. Joret, Stephen J. Laskowski, John W. Lynch, Gordon S. Meyer, Martin J. Murphy, Francis X. P. Powers, George Reilly, Ernest M. Riedel, and Thomas Zaia; (Vietnam) Edward J. Breen, Timothy Daly, Kevin Kennedy, Eugene O'Connell, and Thomas Schiess.

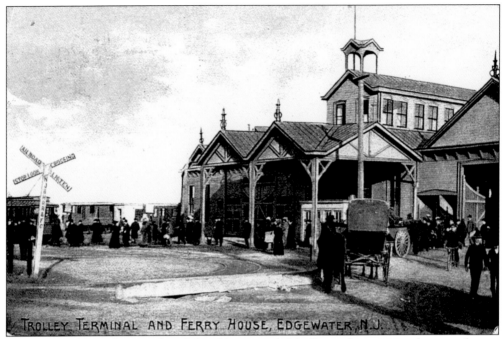

One of the oldest photographs of the Edgewater–125th Street ferry terminal comes from a postcard before the advent of automobiles. Note the horse-drawn carriages waiting to meet the ferry in Edgewater.

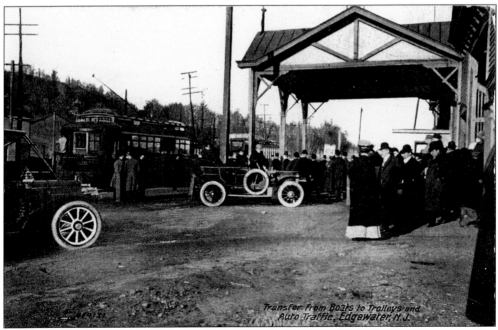

A photograph taken from a different angle shows trolleys waiting for the ferry in Edgewater. This later postcard scene shows that automobiles have now replaced horses.

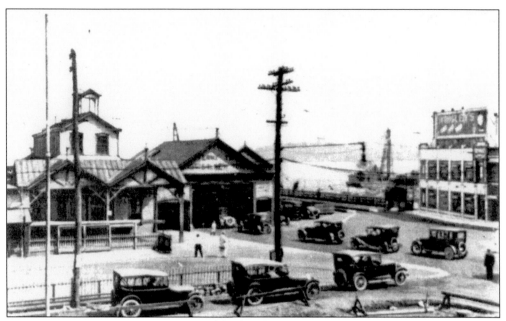

It was a common scene in the 1920s and for decades after that to see cars lined up to get on the ferry. Sometimes, the line of cars would back up Route 5 waiting for the ferry.

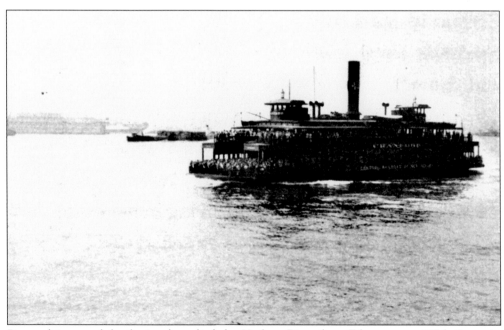

Pictured is one of the ferries that plied the Hudson River from Edgewater to 125th Street in Manhattan. In 1926, this ferry service was so popular that it set a new record on a Sunday in September, when the service transported 11,040 vehicles and 53,703 foot passengers.

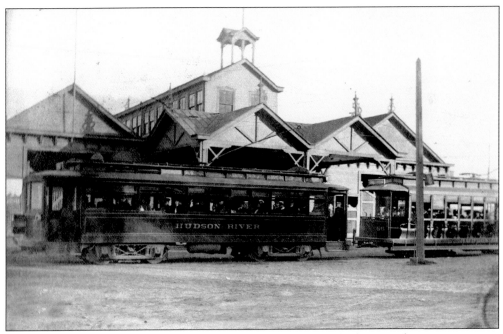

Trolley cars at the Edgewater ferry terminal are shown in a view looking south.

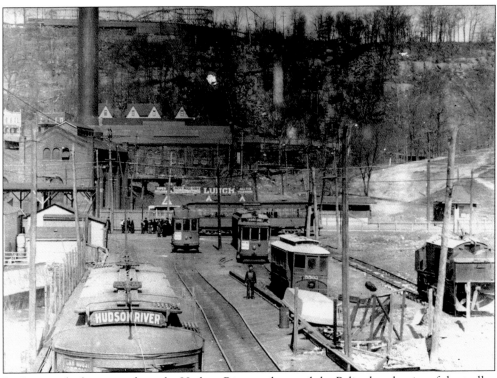

In this view looking west from the Hudson River and toward the Palisades, the size of the trolley terminal at the ferry stop is illustrated.

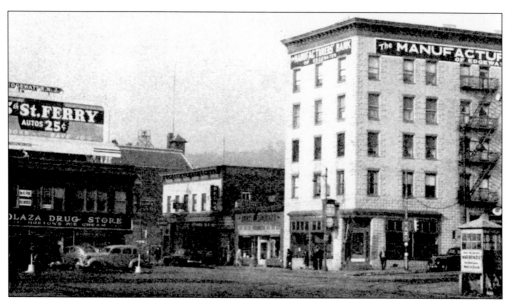

Shown is downtown Edgewater in the 1940s: Dempsey Avenue and River Road. The ferry terminal is across the street, mostly out of camera range. But at the left is the Plaza Drug Store, part of the ferry terminal. Note the billboard above the store promoting the ferry where cars could be transported for 25¢. The Manufacturers' Bank building, across the street on the southwest corner of Demsey and River, was razed in the late 1990s. The terminal building was torn down to make way for a building that now houses apartments and the Mariner's Bank. Prior to its demolition, this building was used for numerous scenes in the filming of *Cop Land* (see page 48). A high-rise apartment building now sits where the photographer stood to take this photograph.

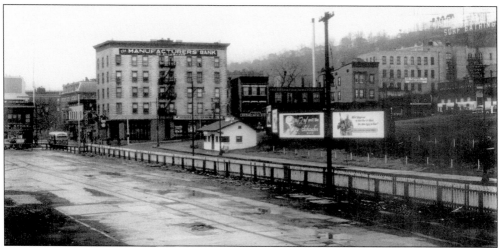

A longer shot of the Dempsey Avenue and River Road intersection shows the corner opposite the Manufacturers' Bank building now occupied with a small building and billboards. The billboard at the right is making a point about Korean War veterans, dating the photograph to the 1950s. Manufacturers' Bank began operations in January 1935, just as the Edgewater Trust Company was being liquidated. The new bank took over the only assets of the old bank: the building, furniture, and fixtures. The site, once the location of Taylor's Hotel (see page 65), is now occupied by a bank.

A much earlier photograph of Dempsey Avenue at River Road shows a horse and carriage waiting by the trolley tracks, which turned up the hill on Dempsey from River Road.

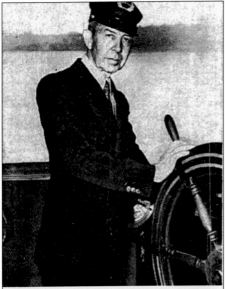

MAKES 250,000TH CROSSING OF THE HUDSON
Captain John J. McCabe at the wheel of his ferryboat yesterday
Times Wide World

Special to THE NEW YORK TIMES.

EDGEWATER, N. J., July 10— Captain John J. McCabe, who is serving his thirty-fourth year as a skipper of ferry boats between 125th Street and Edgewater, made his 250,000th trip at 11 o'clock this morning and received a commemorative plaque from the owners of the Palisades Amusement Park. Ceremonies were held both on the New Jersey and New York sides of the ferry.

Although averaging twenty-two trips a day, Captain McCabe has never had an accident and never had the urge to turn his boat off the course for a trip up or down the river.

He recalled that in the earlier years of his career he took many celebrities across the river, including "Diamond Jim" Brady and Lillian Russell, who used to cross to New Jersey for tandem bicycle riding, and the late Douglas Fairbanks, the Gish sisters, Mary Pickford, William S. Hart and D. W. Griffith, who were passengers when Fort Lee was the center of the motion picture industry.

Captain McCabe is 67 years old, the oldest captain on the staff of the Public Service Coordinated Transport Company, and is eligible for retirement next year.

On July 11, 1940, a ferry captain plying the Hudson between Edgewater and 125th Street, Manhattan, earned some degree of fame, as noted in this *New York Times* report.

The ferry stopped running on December 16, 1955. Here is a family in their car about to drive on to the last ferry. Note the fare for passenger cars was raised to 35¢. Before the Edgewater–125th Street ferry was established in 1894, there were a number of ferries that ran from various locations in Edgewater to as many different locations in Manhattan. Ferry service from Burdett's Landing in the Edgewater Colony goes back before Revolutionary times. There were also ferries running in the 19th century from Shadyside. On March 1, 1849, Francis R. Tillou was granted the right to operate a ferry from his property, a large estate in what was then known as Pleasantville that cut a swath from the Hudson River to the Palisades that included Valley Place and Hudson Avenue. Tillou, a successful Manhattan attorney, lived in a house located where the library now stands at the corner of Undercliff and Hudson. He called his estate Tillietudlem.

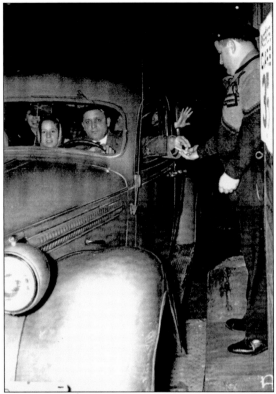

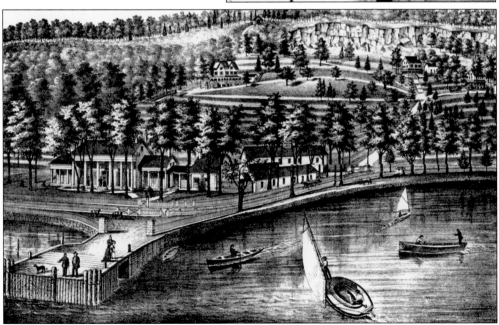

This artist's sketch shows the dock Francis Tillou constructed for the ferry service that brought many celebrities and important persons of the day to his estate, including the infamous New York City political leader Boss Tweed. The dock is in the approximate current location of the Edgewater Marina and Ferry Stop.

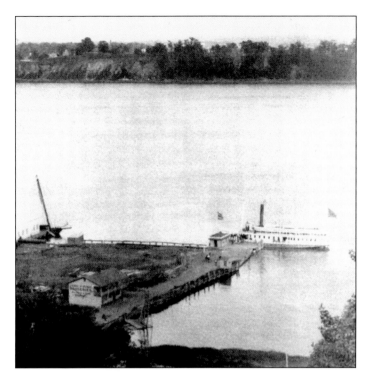

Another early ferry service is shown making a stop at Winterborn Dock, at the foot of Oxen Hill. This ferry made four stops on the New Jersey side of the Hudson: one in Fort Lee and three in Edgewater. Ferry service helped make Dempsey Avenue and River Road the center of town, as did the post office, which was located in the ferry terminal building. But the post office moved to Hilliard Avenue in 1936.

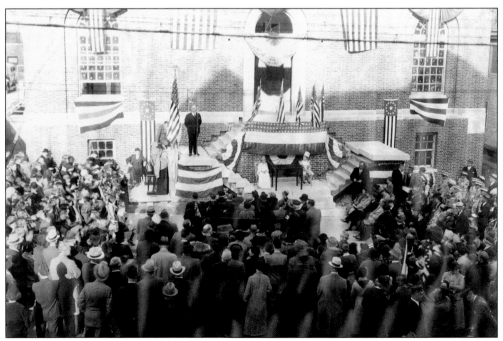

The new $65,000 post office building on Hilliard Avenue was dedicated on October 24, 1936, in ceremonies that featured an address by Rep. Edward A. Kenney. A parade preceded the exercises, presided over by postmaster Emory Benoit. Mayor Henry Wissel was chairman of the committee that planned the day.

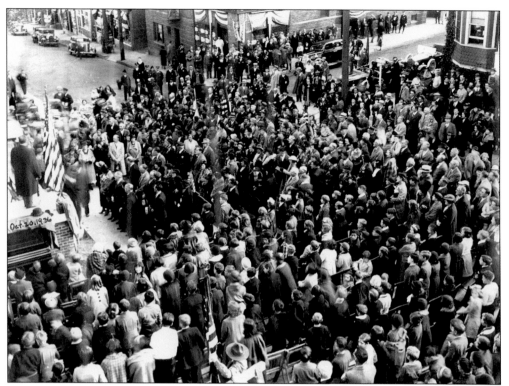

Another photograph taken on the day of the post office dedication shows the crowd gathered in the street on Hilliard Avenue and Edgewater Place for the ceremony. The new post office served the town until a larger one was constructed and opened on November 21, 2001, on River Road at Russell Avenue.

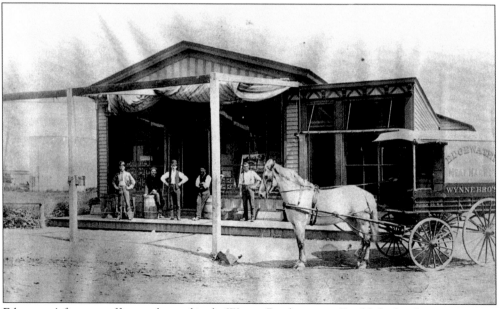

Edgewater's first post office was located in the Wynne Brothers store. Established on January 21, 1879, at the Winterburn estate, it was operated by John A. Winterburn, the town's first postmaster.

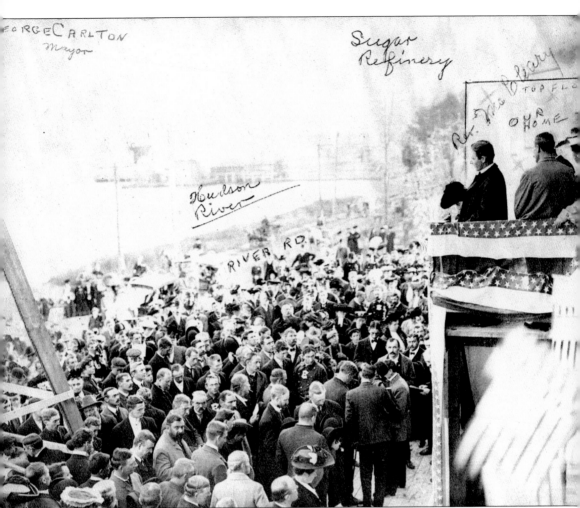

Shown is the 1904 dedication of borough hall, at the corner of Hilliard and River Roads.

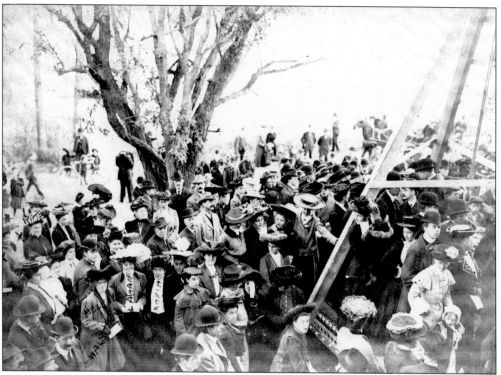

A crowd gathers in front of borough hall for its dedication.

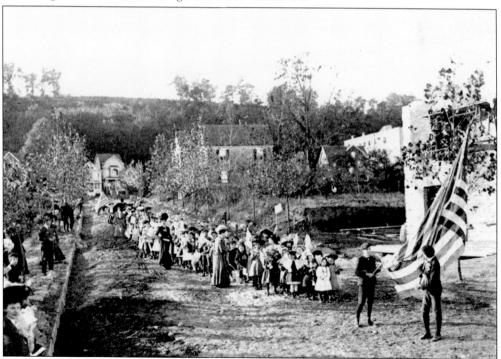

Schoolteacher Eleanor Van Gelder leads her classes up River Road to the dedication of the new borough hall. Note the student leading the way, carrying the American flag.

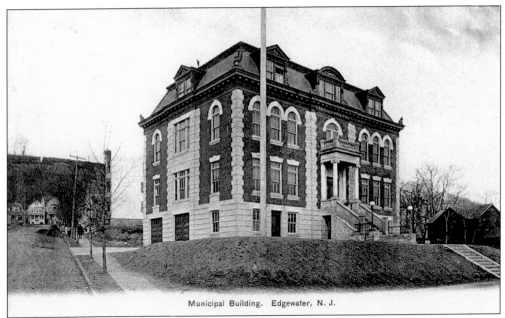

Municipal Building. Edgewater, N. J.

The new borough hall, pictured in the early 1900s, was designed by John V. Signell. Note the details of acroterions in each of the corners of the lower ledge of the mansard roof. All are missing today, but one was recently found in the attic of the building. On the order of gargoyles, the copper decorations are in the form of large birds.

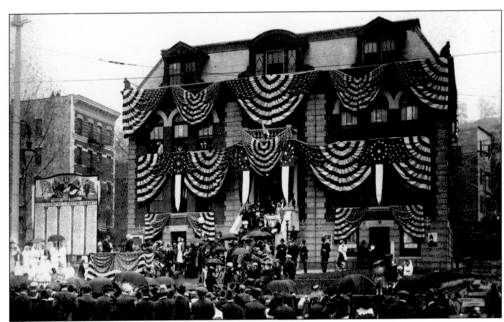

Decked out in bunting, the borough hall is pictured at the end of World War I. The World War I honor roll is at the left.

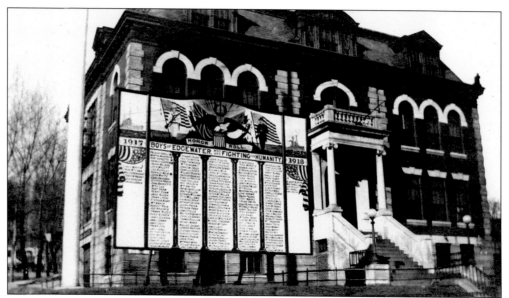

The World War I honor roll stood in front of borough hall during the war years.

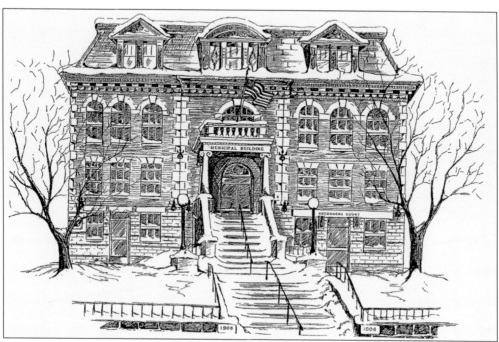

This sketch of borough hall in winter, done by Ed DeWitt, hangs in the borough council chamber behind the mayor's seat.

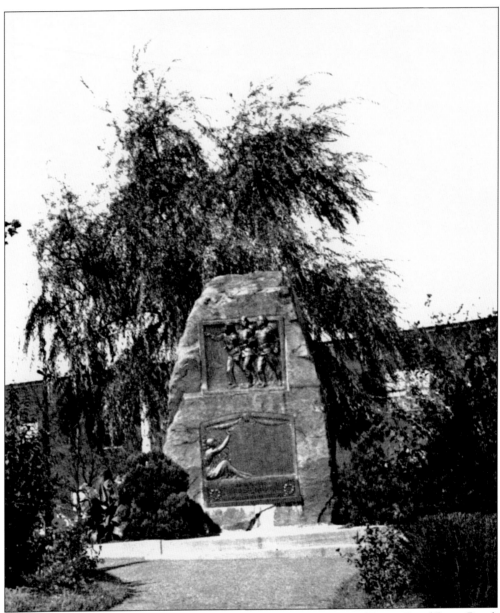

Just north from Dempsey Avenue is Memorial Park, at the junction of Route 5 and River Road. Here, the Soldiers and Sailors Monument stands, with a bronze memorial bas-relief mounted on rock. Dedicated on Memorial Day 1925 in ceremonies led by Mayor Henry Wissel, the monument now contains the names of all of those residents who died in the service of their country in three wars: World Wars I and II and Vietnam. The World War I memorial, shown above, was executed by sculptor Ettore Cadorin (1876–1952), who was born in Venice, Italy, on March 1, 1876, and studied under Auguste Rodin. The work is a bas-relief approximately two feet tall of servicemen representing three branches of the service. The other side of the large stone includes tributes to those who died in World War II and Vietnam. There is also a plaque noting those who served in the Korean War.

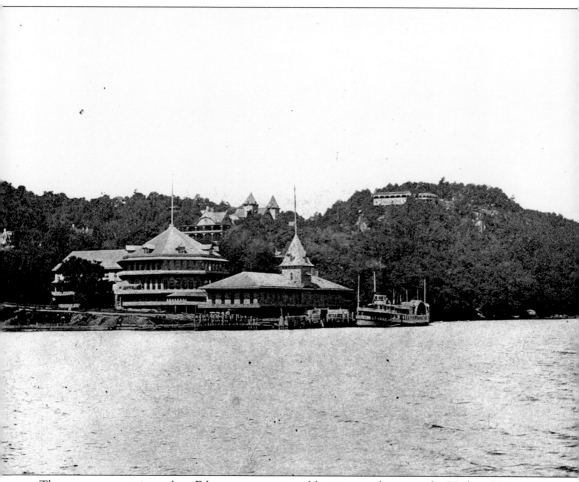

There once was a time when Edgewater was viewed by city people across the Hudson River as a destination for a getaway, sometimes a day trip for a summer picnic or a longer stay at one of several hotels in the sleepy, pastoral little town in the late 1800s. One of the more palatial accommodations was the Fort Lee Hotel and Pavilion or Octagon House. Opened in 1878, it was located on the Hudson in what later became the Edgewater Colony. Its 60 rooms each had gas lighting, and the hotel had its own ferry service from its grounds to 129th Street in Manhattan. Guests were provided with picnic grounds, band concerts, a roller-skating rink, outdoor shows, and rustic walkways. It all came to an end in 1898, when the hotel burned down. The owners decided not to rebuild. Some of the octagon-shaped foundation can still be seen.

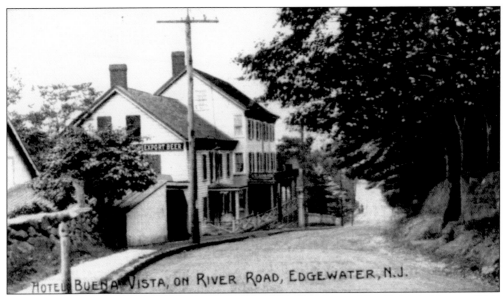

Another favorite was the Buena Vista Hotel on River Road near Von Dohln's Marina. This smaller section of the building was built by a member of the Burdett family in 1780. In 1870, it was operated by a Mr. Delamar as the Sarah Bernhardt Hotel, and the actress was on occasion a guest there. Others who signed the guest register in the early 1900s included D. W. Griffith, Mac Sennett, Mary Pickford, Pearl White, and the Barrymores. The place served at one time as a shoe factory and then as a military academy in 1880, when it was operated by a Dr. Boescher. Later, it again became a hotel. Today, with the smaller section (near side) having been removed, it serves as a multifamily residence.

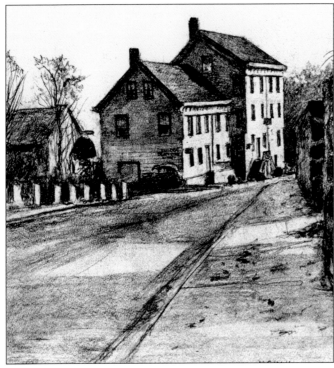

The Buena Vista is shown as it looked in 1936. Thesketch was done by H. G. Williamson.

64

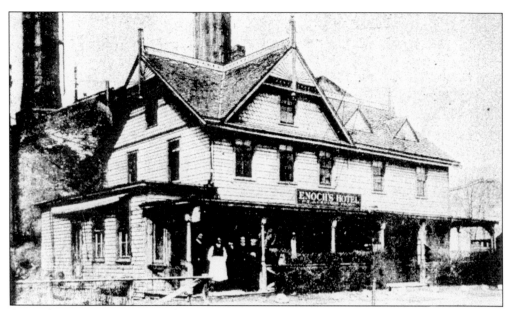

A popular tourist stop was Enoch's Hotel, located on River Road, across from the ferry terminal. It was operated by Enoch J. Carlson. The Glasser Hotel, which opened in 1897 at Ferry Plaza, moved across the street when the ferry terminal was constructed.

One of the oldest known hotels in Edgewater was Taylor's Hotel (previously Conway's, as it stood on the Conway estate, and the Pleasant Valley Hotel). Alonzo Taylor was the proprietor. It included a dance pavilion, erected 100 years earlier in 1779, and a 12-acre picnic grove. It burned down on September 22, 1879. The *New York Times* carried a colorful account of the fire and, on September 4, 1879, a write-up of an event that took place at the hotel shortly before the fire.

FAT MEN EATING CLAMS

THE "HEAVY WEIGHTS" CLAM-BAKE

A PONDEROUS GATHERING AT PLEASANT VALLEY, UP THE HUDSON—HOW TO MAKE THE "BAKE" AND HOW TO DISPOSE OF IT.

The "Heavy Weights," a society organized for the express purpose of eating clams and chickens, enjoyed their thirteenth annual clam-bake at Taylor's Hotel, in Pleasant Valley, N. J., yesterday. After a series of 12 annual clam-bakes, previously eaten, it could not but be expected of these gentlemen that they should reach the proportions of members of the Fat Men's Club; and they fulfill every reasonable expectation. They have been in training for a long time, and have missed no opportunity for development, and now the majority of them look very much as Jonah must have looked immediately after he swallowed the whale. A large proportion of the members are heavy weights not only in avoirdupois but otherwise, and can put their hands in their pockets and draw out very comfortable sums, when occasion requires. Mr. John Green, the President, is also President and principal owner of the Forty-second-Street Horse Railroad, and he kindly lets all the members of the society ride over his road for half fare. That is, he would ordinarily charge them 10 cents on account of their immense weights, but he lets them ride for the usual price of 5 cents.

About 75 of the members assembled yesterday to increase their weights, and they were accompanied by about 75 of their friends; and when they got through, the landlord said there wasn't enough "chuck" left in the house to feed a cat.

Gen. Alonzo Taylor, of the Pleasant Valley Hotel, presided over the clam-bake, out in the back yard; and under his management a Pleasant Valley clam-bake is a little different from any other bake. A small pavement, about 6 feet by 12, is made with large stones. On this a huge, blazing fire is built several hours before the bake. When the stones are well heated, the embers and ashes are swept off, and the bake is begun. The corn, potatoes, and clams are put in little wire baskets, each basket containing enough for one or two persons. The baskets are laid on the hot stones, several layers thick, the layers decreasing in size toward the top, in pyramidal style. On top of the wire baskets are laid plates containing blue-fish, eels, and chicken. A little sea-weed is then laid around the edges of the pile, and a piece of clean white muslin is stretched over the pyramid, which, by this time, is about 4 feet high. A thick piece of old sail is laid over this, and the whole is then covered with a layer of sea-weed.

THIRTEEN LIVES IN PERIL

A HOTEL BURNED IN THE DEAD OF OF NIGHT.

DESTRUCTION OF TAYLOR'S HOTEL AT PLEASANT VALLEY ON THE HUDSON—HOW THE OCCUPANTS ESCAPED IN THEIR NIGHT-CLOTHES.

One mile south of Fort Lee, nestled in a green little nook by the Hudson, stands a group of four or five cozy farm-houses, shaded by spreading elms and black walnuts. The place is designated Pleasant Valley. There is a forest in the background, and a high hill, crested with woods, behind which the sun drops at 4:30 in the afternoon of a September day. Taylor's Hotel, a long two-story building, with many windows and verandas, occupied the foreground of this pretty scene until yesterday morning, when the people living in the neighborhood awoke to find that it had vanished while they slept. At sunset last night three men sat on a stone beside the wood in front of the ruin, and smoked their brier-wood pipes moodily. Now and then a sympathizing neighbor joined the group and gossiped to the men of their loss. One of them, a stalwart man of 35, with masses of brown hair straying over his forehead, was Rome Volk, formerly manager of the hotel whose smoking embers he contemplated in gloomy silence. When asked what the matter was his laconic answer was, "cleaned out;" and then, by way of explanation, pointing to a particular spot near the fire-place. "All I had in the world lies there somewhere, and here I am sitting on a stool, not worth a red cent. These old shoes," pointing to his feet, "and the pantaloons I have on belong to me; but the shirt and hat I borrowed from a friend this morning. My wife is no better off than I am. That is what's the matter with me." His companions in misery removed their pipes from their mouths at this juncture, and corroborated the Superintendent's story. It was about 9 o'clock on Sunday night when Volk went to bed. He occupied a room on the third floor, under the roof, the dancing pavilion being hidden from his window by a jutting gable. An old servant, Jane Mc-Closkey, who did laundry work for the hotel, had

The leading places for social gatherings and entertainment was Clahan's General Store, bar, boardinghouse, and burlesque theater in the Shadyside section of Edgewater. It was founded by John Clahan Sr., who came to Edgewater from Brooklyn and opened his store six years later. Located between Gorge Road and what is now Old River Road, some of the original buildings remain today as the River Gorge Inn.

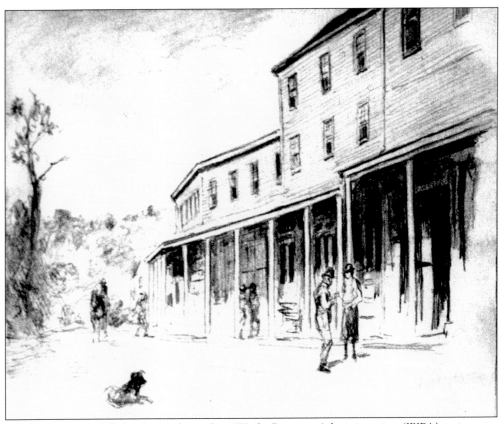

A different view of Clahan's was drawn by a Works Progress Administration (WPA) artist.

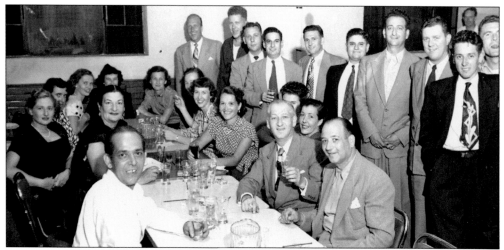

Although Edgewater (because of its small size, low population, and domination by industry) never had any retail outlets, it has, for more than 50 years, had a chamber of commerce. Attending a chamber gathering in 1951 are, from left to right, the following: (at table) Mrs. Jules Blaustein, unidentified, Helen Von Dohln, Mrs. Robert Cavalier, Edith Cannock, Ruth Nunn, druggist Robert Schmorack, and Leon Schmorak (Robert's brother); (standing) insurance agent Fred Hanson, unidentified, chamber president Al Cannock, Harold Blaustein, Jim Nunn, Terminal Liquor proprietor Jules Blaustein, barber Robert Cavalier, Owen Shaheen, and Al Von Dohln.

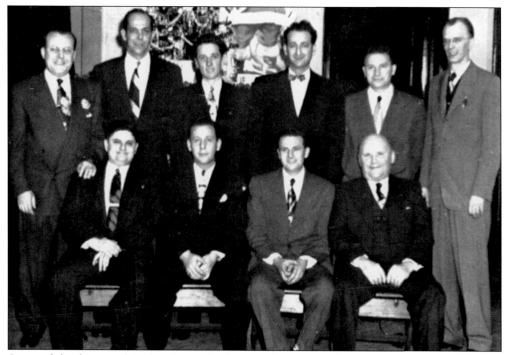

Some of the faces at this chamber gathering are the same as those seen in the previous view. From left to right are (first row) Jules Blaustein, Al Cannock, Jim Nunn, and Lubin's Market owner Gene West; (second row) Boro Tavern owner Martin Donley, Buddy Reiss, Al Von Dohln, Bob Cavalier, dry cleaner Fred Quenzer, and *Bergen Citizen* newspaperman Fred Grown.

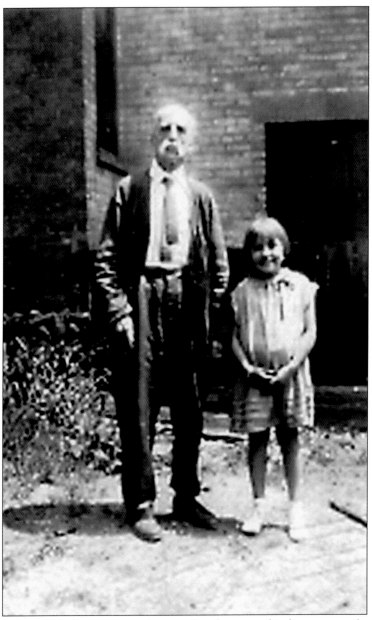

Edgewater may have lacked some conveniences taken for granted in larger towns (a supermarket was not opened until 1996), but the town had two weekly newspapers for most of the 20th century. The existence of the *Borough News* and *Bergen Citizen* was due to Dr. Benoni Underwood, a multitalented physician from Brooklyn who settled here in the early 1900s. He founded both papers and kept them going with his son Elliott Underwood for more than 50 years. Dr. Benoni Underwood, shown here in 1931 with his granddaughter Dorothy Jones, not only founded the Underwood Press but also edited medical journals and wrote homeopathic textbooks. Furthermore, between 1900 and 1910, he authored 14 boys' books in two series—the Boy Scouts and the Comrades—under the pen name of Ralph Victor. When he died in 1932 at age 89, his obituary in the *New York Times* noted he was a staunch Republican who cast his first vote for Abraham Lincoln and his last vote for Herbert Hoover.

SOUVENIR gems

From the desk of the

MOTHER'S DAY

Some folks love us when we're Good
Others, when we're Bad.
Some folks love us when we're Gay,
Others, when we're Sad.
It takes same special quality
To win the World's applause.
But Mothers are the only ones
Who Love us just "because."

The years have altered the form and the life
But the heart is unchanged by time;
And still he is only your boy as of old.
O beautiful Mother of mine!
Mother in gladness,
Mother in sorrow,
Mother today, and Mother to-morrow,
With arms ever open to fold,
and caress you,
O Mother of Mine, may God Keep you, and Bless you.

The difference between amnesia and magnesia is, according to C.V. Hunt, that the fellow with amnesia doesn't know where he is going.

* * *
There were 620,000 divorces granted in the United States in 1947 which is almost double the figure for 1942.

* * *
A contributor to this column

The Bergen Citizen

RIDGEFIELD FAIRVIEW CLIFFSIDE PARK FORT LEE

VOL. XL, NO. 19 — FRIDAY, MAY 12, 1950 — PRICE FIVE CENTS

Florists Object To Food Store Sale Of Plants, Flowers

A protest about the sale of flowers and potted plants by vegetable and chain stores was received at a meeting Monday by the Cliffside Park Mayor and Council from a florist of 662 Anderson avenue. They contended the selling of flowers by the competing stores constituted a menace to their business, and requested that the Council take steps to ban stores other than those concerned mainly with flowers and plants to sell them.

The communication was referred to committee.

Plans will be drawn for a new Borough Hall and free public library. It was indicated by Councilman Frank Safino, and selected for the job was architect Robert J. L. Carden of 570 Gorge road, who will be paid with federal funds.

Mayor William T. Michaelsen said that the planning would not cost the Borough anything unless the buildings are actually constructed.

Councilman Edward Ulrich was presented with a souvenir copy of a memorial album commemorating the work of the late Mayor William T. Michaelsen Memorial Plaque Committee, of which he was chairman at the conclusion of his final report on the memorial Commander Lawrence Becker of Epiphany Post, Catholic War Veterans. Prior to receiving his album, Ulrich had given a similar one to Mayor Michaelsen.

Mayor Michaelsen and Mrs. William T. Eissing of 766 West End avenue harangued about the draining of the Kingsland avenue swamp. Mrs. Eissing told the Mayor that she felt that it was unfair to herself and her neighbors that the sewer which she claimed cost the

RIDGEFIELD WOMAN, 81, STRUCK BY N. Y. CAB

Mrs. May H. Smith, 81, of 945 Ray avenue, Ridgefield, escaped serious injury Wednesday afternoon when a taxicab struck her as she was crossing Seventh avenue near 33rd street in New York.

An ambulance took her to St. Vincent's Hospital where she was released after treatment. The cab was driven by Gerard Maneco, of Brooklyn, police said.

DRIVE ON TO MAY 20

Mrs. William Hanna, Fairview, chairman for the cancer fund drive, has announced that the campaign has been extended to May 20, to enable the borough to attain its quota.

Geerinck Says Green Council Needs A Map To Find Town's Roads

The Ridgefield administration was described as being so inexperienced that councilmen required a map of the Borough in the Council chambers to find their way around, at a meeting of the Republican Club Monday night by former Councilman Gerard J. Geerinck.

The borough government was now one by appointees who Geerinck said, were handpicked by the political bosses. Geerinck said that the entire Council was unable to cope with the municipalities' problems by reason of inexperience, and he stated that the only elected official with more than two years experience, was Acting Mayor Howard Mayer.

Of the three incumbents running for office in November, Geerinck said, only one, Mayer, was actually elected. The other two, William

(continued on last page)

MRS. BLANCHARD DIES AT GRANTWOOD HOME

Mrs. Blanche Adele Blanchard, 61, was found dead at her home, 436 Anderson avenue, Cliffside Park, by her daughter when she returned home from work at 6 o'clock Wednesday night. Dr. John Williams, of Cliffside Park, made the pronouncement of death and said she had been dead since morning.

Captain John J. McEvoy on his way home for dinner, received a call by radio just as his car was passing the house. Accompanied by Patrolman John Gerrity, he entered the apartment where Mrs. Blanchard lived with her daughter.

Mrs. Blanchard was found lying across the bed, and was apparently stricken, as she was preparing to leave for work in New York.

Elliott Underwood Started Weekly In 1910, Dies At 76

Elliott Underwood

Funeral services for Elliott Underwood, 76, retired editor and publisher of the Borough News of Edgewater, were held Wednesday morning at McCorry Brothers Funeral Home in Grantwood, with the Rev. Albert E. Phillips, rector of the Episcopal Church of the Mediator, Edgewater, officiating. Cremation was the New York and New Jersey Crematory, North Bergen.

Ritualistic services were conducted Tuesday night by Whitehead Lodge, F. and A. M. of which Mr. Underwood had been a member. The Men's Republican Club of Edgewater, headed by Mayor Henry Wissel and Cyrus LaVerdure, president, postponed its meeting Monday night and members paid their respects at the funeral home.

Stricken with a heart attack Sunday morning, Mr. Underwood was pronounced dead shortly before noon by Dr. Charles F. Buckley, police surgeon, after unsuccessful efforts by Edgewater firemen to resuscitate him. His wife, Mrs. Lillian V. Underwood went to fire headquarters at about 1 a.m., and Lieutenant Kenneth Gotthold and Firemen John Lasher and John Kelly responded with the inhalator. After administering oxygen for more than an hour, the firemen left but were recalled about 10 minutes later.

Besides his affiliation with the Masonic Order and the Republican Club, Mr. Underwood was secretary of the Edgewater Board of Trade until its dissolution about 20 years ago; he also served on the Sinking Fund Commission of the Borough until the group was discontinued.

Wissel Serves Shad To GOP Mayors

Mayor Henry Wissel of Edgewater was host Friday night at the annual shad dinner of the Bergen County Republican Mayors Association at the Colonial Grill in Edgewater. For the first time a woman was among the 200 guests, Wilma Marggraf, member of the Assembly.

Other guests included Senator David Van Alstyne, Congressman William B. Widnall, Judge Joseph W. Marini, Judge John D. Lynn, Freeholders Martin Ferber and Dr. Samuel Alexander, County Treasurer Theodore Holmes, County Medical Examiner Raphael Gilady, Assembly-

EDGEWATER
ITEMS of INTEREST

Frank Ravese, who operates a grocery and butcher store at 14 Hilliard avenue, is in Italy visiting relatives.

The Good Will Society of the Episcopal Church of the Mediator, at a meeting Wednesday night at the home of Mrs. Oscar Von Utter of 40 Hudson avenue, decided to postpone the card party scheduled for May 24 until a later

The final ice skating trip of the season will be held tomorrow by the Edgewater Skating Club, under the supervision of Mrs. Margaret Toolen, director.

The Rev. Ralph K. Galloway, pastor of the First Presbyterian Church, announced that the sermon topic for Sunday at 11 a.m. will be "Mother's Day". The Junior choir

PHIL COOPER DIES; FOUNDED CLEANERS

Phil Cooper, who founded the cleaning and dyeing plant in Edgewater under his same name more than 25 years ago, died Saturday at his home at 490 West End avenue, New York. He had retired from the business some two years ago. Burial took place Sunday.

Cooper is survived by his wife, Mrs. Clara Cooper, a son, William, a daughter, Mrs. Miriam Miller, and two grandsons.

The lead story of the *Bergen Citizen* from May 12, 1950, tells of the death at age 76 of Elliott Underwood. The paper also shows that Mayor Henry Wissel was hosting mayors of surrounding towns at a shad dinner at Edgewater's Colonial Grill. For the first time, this previously all-male annual event was attended by a woman, Assemblywoman Wilma Marggraf.

69

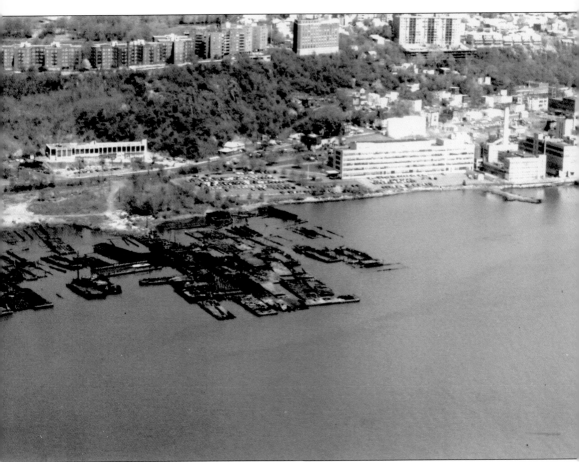

When Edgewater was at the beginning of a transition from a factory town to a waterfront community of homes in the 1960s, a series of aerial photographs were taken of the three-mile riverfront. The result is a panorama of a few remaining factories, empty lots that had been cleared of their industrial facilities, and a couple of early multiple-home developments. Beginning at the southernmost part of Edgewater, which abuts the next county and next town (Hudson and North Bergen), this aerial view shows a portion of North Bergen and, at the right, the Unilever factory. Today, Unilever, which once manufactured Spry shortening and soap products here, has been cut back to a research and development facility, soon to be closed. Plans are being made to redevelop this land for multipurpose uses: retailing and multifamily housing.

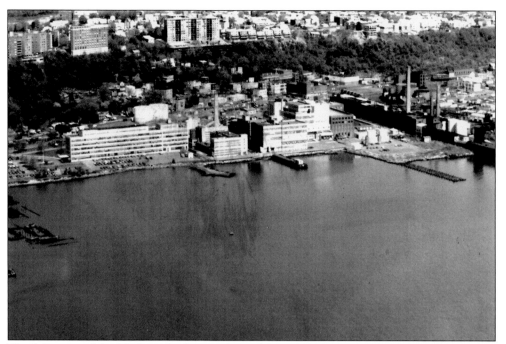

The full scope of the Unilever facilities is shown here.

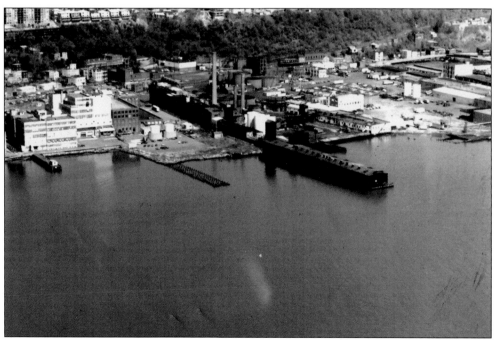

Along with the northern end of the Unilever complex at the left is a long dark building with a pier extending into the Hudson River. This structure was once the largest linseed oil processing plant in the world, Spencer Kellogg & Sons. Today, at 115 River Road, it is occupied on the River Road side (western end) by Interchange Bank (formerly Bridge View Bank) and in other sections by businesses and a preschool day-care center. At the right is a portion of the Celotex complex.

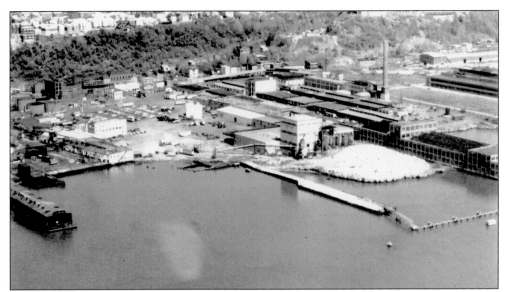

This view shows the Quanta Resources Superfund site, controlled by Honeywell Corporation, a tract that once housed one of the oldest industries in the borough, the Barrett Corporation, which produced coal tar from 1896 until 1974. Nothing has been built on this site, as it is in need of an environmental cleanup. Farther to the right is the Celotex complex, which once manufactured Sheetrock and other building materials. Today, this is the site of an upscale community of apartment units, shops, and eating places. A hotel is the latest addition to this site. It is known as the Promenade. The old industrial pier, at the far right, was utilized to build apartments.

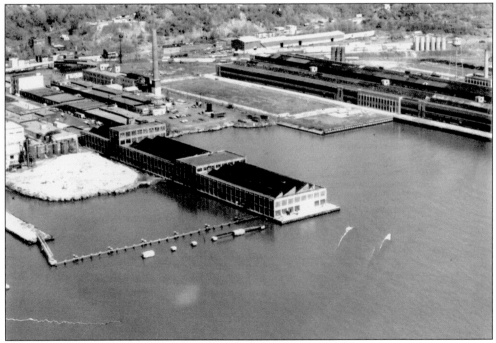

This photograph shows the full extent of the Celotex pier that has been converted to apartment units. To the right, a navy pier and a portion of the Ford assembly plant can be seen. The navy pier land is now occupied by the Sunrise assisted-living facility and a multiplex theater.

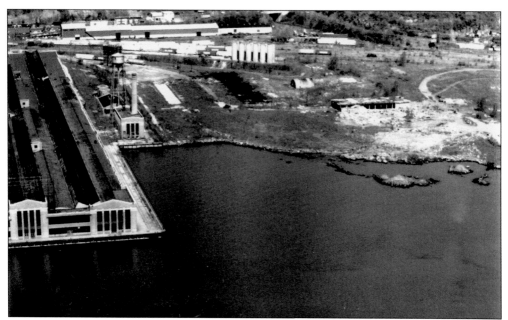

This view shows the Ford assembly plant (left), now the site of the Independence Harbor condominiums. Land to the right was occupied by what was known as Pier A and housed a trucking firm and a cocoa factory. The pier area is occupied by the River Club, an apartment complex.

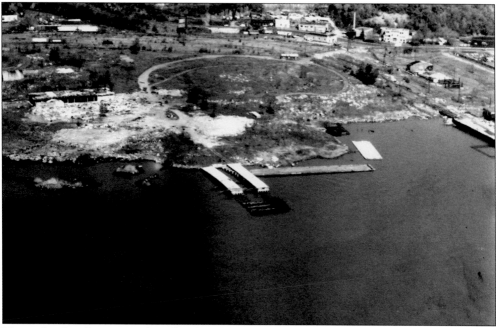

Vacant land and remains of an abandoned building dominate this scene, another view of what today is the site of the River Club, a rental community. Missing from this photograph is the new River Road, which departs from what is now called Old River Road near the small smokestack at the upper right, the location of the borough's sewage-processing plant. The new River Road heads directly south, providing access to what was once industrial acreage.

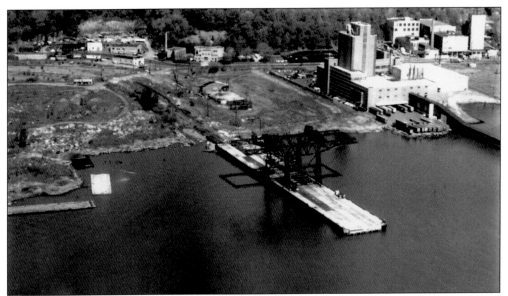

Hills Brothers brewed coffee in the factory at the right. The vacant land to the left of that building was once occupied by SeaTrain, a company that took freight from railroad cars and loaded it directly on to ships, thereby competing with railroads that ran from New Jersey to Florida. After the company closed, the pier in the center of the photograph was demolished, and the site was developed as the strip mall Edgewater Commons. The River Club property is at the far left.

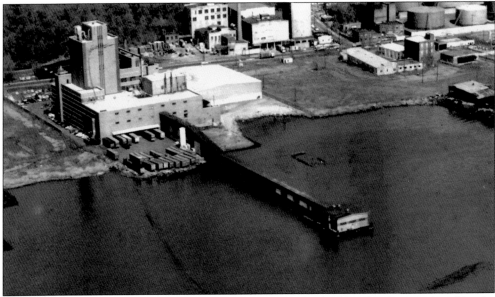

This is another view of the Hills Brothers coffee factory. This building has been replaced by the Edgewater Golf driving range. Octagon Processing, which began as an Archer Daniels Midland linseed oil plant, can be seen at the right on the west side of River Road, which intersects the Hess Oil tank farm, also at the right. Octagon, the manufacturer of chemicals including deicing substances for the aviation industry, is slated for demolition and replacement by two 12-story apartment houses.

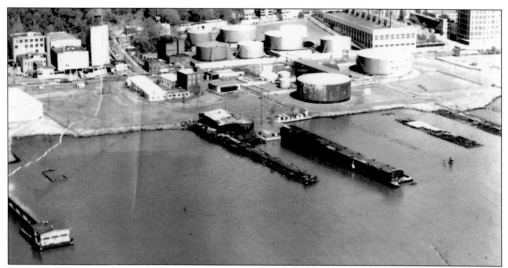

Northward along the Edgewater riverfront is the Hess Oil storage facility for heating oil, an active operation. This area has not changed appreciably in more than 40 years. Note the empty land to the left of the Hess facilities. This area is now occupied by the Mitsua Market Place, a Japanese supermarket, a restaurant, and other Asian shops. It was formerly Yaohan, also a Japanese supermarket, which opened in 1988.

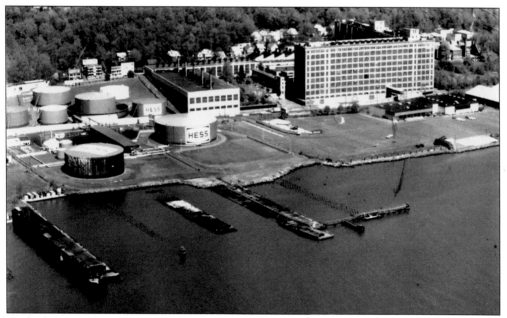

At the left is the Hess Oil tank farm, the only significant industry left in the borough. The balance of this photograph shows Alcoa Aluminum, with its main factory to the right and its rolling mill, the smaller building, to the left. Between these two buildings is small plot of land that is the Edgewater Cemetery, which holds the remains of several Civil War veterans. Alcoa's main building was razed after Gov. Christie Whitman visited Edgewater on January 6, 1998, to sign a bill to encourage developers to build on pollution-tainted "brownfields." The old factory was replaced by a low-rise complex of apartments, Avalon at Edgewater. The rolling mill building remains, standing vacant and with a portion of it at the western end removed to create a small park.

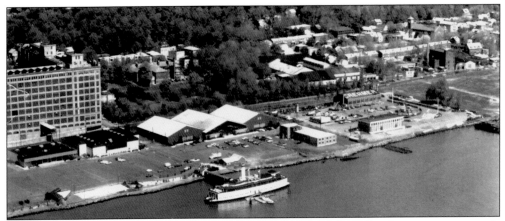

In the center, at water's edge, is the former Erie Railroad ferryboat *Binghamton*, permanently anchored offshore and serving as a restaurant. The ferryboat was built by the Hoboken Ferry Company and launched in 1905. It plied the Hudson River, first from Jersey City at the Erie Railroad terminal and then from Hoboken when the Erie merged with the Delaware, Lackawanna & Western Railroad in 1960. The ferry then became part of the fleet of the merged Erie-Lackawanna and sailed from Hoboken. The double-ended steamboat took passengers to Barclay Street in Manhattan for 62 years. It could carry 986 passengers, as well as a number of vehicles. In operation until 1967, it was brought to Edgewater in 1975 and was listed on the National Register of Historic Places in 1982. The Binghamton retail area, shown here, is considerably smaller than it is today, but the theater, now closed, and Binghamton Tennis Club (with the three peaked roofs) can be seen at the western side of the parking lot. The Binghamton Inn, now a Comfort Inn, is to the right (north) of the parking lot. Across from the Binghamton complex is the Alcoa Aluminum plant.

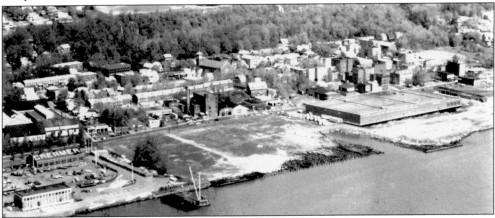

At the right is the U.S. Mailbag Repair facility, since converted to Whole Foods Market and other stores. Before being converted, the U.S. Postal Service operated the building as a center for the repair and servicing of large canvas mailbags. Note the open land to the left of the mailbag building, now occupied by Mariner's Waterfront and the cove communities as well as some business offices, including Mariner's Bank, known as Edgewater Towne Center. At the left is the Creamer car wash, since razed and replaced with the Grand Cove community (825 River Road) and the Landing community. Borough hall can be seen above and to the right of the mailbag building on the opposite side of River Road. In the center, on the west side of River Road, is the sugar mill with its smokestack. This building, part of sugar refining operations that once operated in Edgewater, has since been converted to an apartment complex.

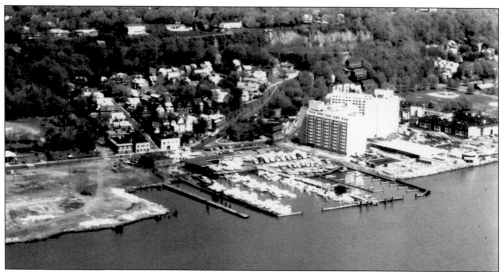

In the center is Edgewater Marina (formerly Grand Cove Marina), and to the right of that are the Admiral's Walk apartments. Beyond that is the Waterside condo complex (1111 River Road). Note the open land to the left of marina, now occupied by the Mariner's Landing high-rise and a complex of low-rise apartments. To the west at its southwest corner is a dark one-story building, which was an auto repair shop and service station. It has been replaced by a modern service station. Just beyond this, River Road is visible, with Dempsey Avenue running to the west and Route 5 running to the northwest. Three buildings on the west side of River Road remain today and house retail establishments with apartments on the second floors.

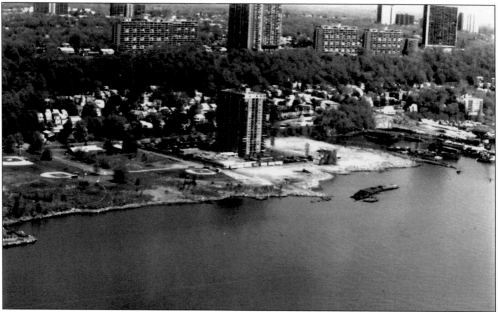

Veteran's Field, with its ball diamonds, can be easily spotted at the left. The high-rise in the center is Hudson Harbor. Note the absence of the community center, which was constructed in 1999. Farther to the west from where the community center now stands is American Legion Post 116. Note the vacant land on the river side of Harbor House and to the right (north) of it, which is now occupied by the Shelter Bay community (1225 River Road).

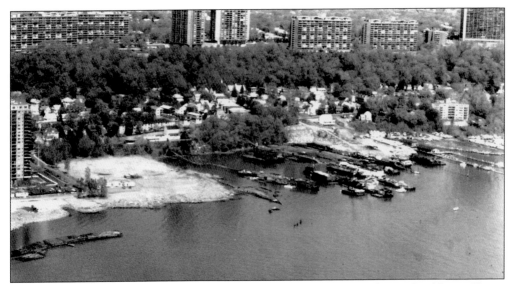

At the left is Hudson Harbor (1203 River Road). At the far right is Caribbean House and, to the right of center, Von Dohln's Marina. Note the open land where Shelter Bay (1225 River Road) is today.

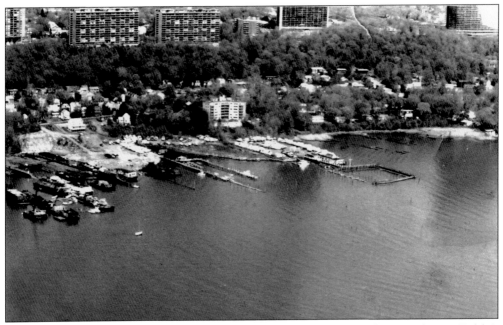

This view shows one of the least changed areas of the Edgewater riverfront, with Von Dohln's Marina at the left and the Caribbean House at the center. The balance of houses near the river are in the Edgewater Colony, an old development in which residents own their homes but not the land, which is held by a cooperative association. Begun as a summer vacation colony, it contains many million-dollar homes today. It is also the site of Burdett's Landing, where the British crossed the Hudson River during the Revolution in pursuit of George Washington's Continental Army.

Four

PUBLIC SERVANTS

Some were high, some lowly. Some did the tough jobs that needed to be done. Some risked their lives. Some were trustworthy and noble; some were not. Some were found guilty of lawbreaking and were jailed. Some were acquitted. Whatever the government, life in Edgewater went on with hope and dreams. Not all dreams came true, but change was constant.

One of the most colorful and longest serving mayors was Henry Wissel. The federal case against the mayor and the other Edgewater officials contended that the mayor had accepted $50,000 to permit 46,000 cases of whiskey valued at $2 million to be smuggled into the United States from a ship from the Bahamas through Edgewater. Before the year of 1927 was out, all convictions were set aside by the Federal Circuit Court of Appeals, which found that a supplemental charge to the jury by the federal trial judge was prejudicial to the defendants.

Mayor Wissel, a Republican, was a very popular mayor and had the support of many residents from both the Democrat and Republican parties. When Wissel was sentenced, a petition that had been circulated in Edgewater was submitted to the court asking for leniency. Many of his supporters who were in the court at the sentencing openly wept, the *New York Times* reported. At the sentencing, Wissel spoke to the court at length, citing his humble origin, his struggle and rise on the political ladder, and his advance from a truck driver to a director of a corporation, Public Service Electric & Gas Company.

The *New York Times* provided his following testimony: "I feel ashamed to take your time, your honor. (State) Senator (Edward) Wakely (who asked the court for leniency) has outlined the situation most happily, I think, but there is a little that I want to say for myself. For many years, I have prided myself upon my successive terms of office and upon the confidence of the people, as shown in the majorities they gave me at the polls. Of course, that is all gone now (there were shouts of 'No, not so,' from those in the courtroom). My opponents will seize on this conviction, and I have no chance for public office. I have been humiliated, even before the trial, by newspaper reports condemning me. I have sacrificed my office, the pride of my life. I have lost my directorships. I owned just enough stock to be a director. I am not a wealthy man, but it was a wonderful thing to me to mingle with men of wealth and position and to sit with them and have them listen to my opinions on business matters. Money isn't everything, Judge. Even now, little children stop me in the streets and tell me they are with me and believe in me. I had hopes of higher office, of being sheriff, of being a congressman, perhaps. At the age of 42, I find my hopes blighted by this unjust verdict. There is nothing the court can do to me that could hurt me more than what has already been done." Wissel died at age 75 on November 26, 1959. His obituary in the *New York Times* described him as a "colorful character" who belonged to the "I-am-the-boss school of politics."

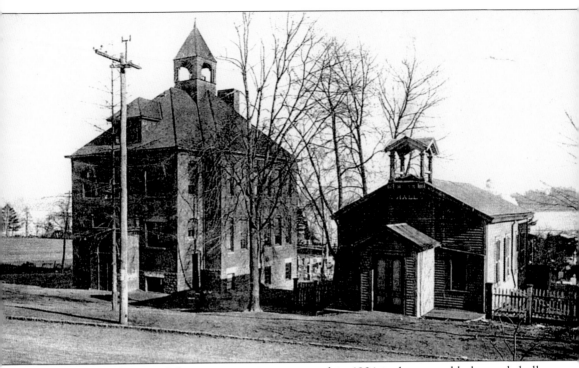

A major focal point of the town since it was erected in 1904 is the venerable borough hall, one of the most distinguished municipal buildings in the area. Its predecessor, shown above, stood next to an old schoolhouse. The early-1900s photograph shows two structures that were supplanted soon afterward. The first borough hall was fashioned in a house that was rented at 176 Undercliff Avenue.

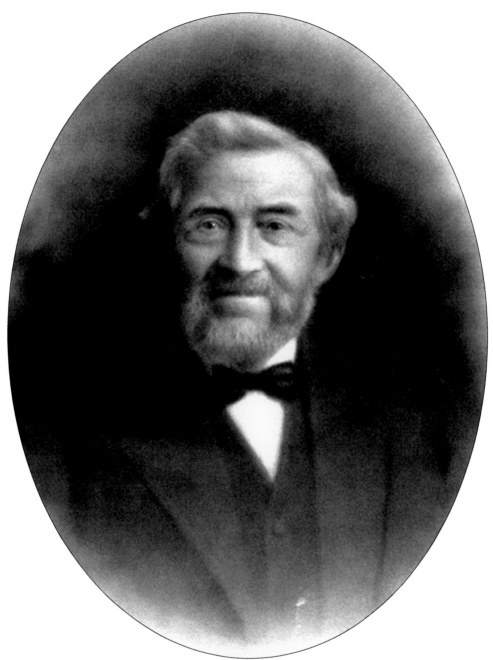

Edgewater's first mayor, Eide H. Hinners, served before the borough of Edgewater was incorporated (1894), from January 15, 1885, to March 15, 1897. Hinners was a principal in Hinners' Sons, builders and building supplies. The company was founded in 1895 as a picture frame molding mill. That business was discontinued in 1915. Edgewater's first borough clerk under Hinners was George H. Nash.

Jeremiah Casey was Edgewater's second mayor, serving from March 15, 1897, to March 20, 1899. He operated the Casey Machine & Supply Company in Jersey City.

Daniel A. Higgins was Edgewater's first mayor in the 20th century, taking office on March 20, 1899, and serving until January 1, 1906. He was associated with the Higgins Dye Works, which was established in Edgewater in 1892.

George A. Carleton was installed as mayor on January 1, 1906, and served in that office until January 1, 1910. He was born in England and lived in Edgewater for 51 years. He died at age 80 in March 1929, leaving a wife and three sons. During Carleton's term as mayor, Edgewater's tax collector Charles Van Gelder fought off a holdup man on River Road by the Edgewater Cemetery on November 18, 1907, thereby saving $400 of the borough's money. The robber retreated and was later arrested at the ferry house and relieved of a revolver by police sergeant O'Brien. He was identified by police as Philip Murphy of Manhattan.

John Clahan Jr. became mayor on January 1, 1910, and served until January 1, 1914. He came from the family who operated Clahan's General Store, part of a complex that included a bar, boardinghouse, and burlesque theater in the Shadyside section of town. On March 28, 1913, Assemblyman Edward H. Hinners and Citizens Committee chairman John J. McGarry asked Mayor Clahan to resign, claiming that if he refused, there would be revelations that would injure the credit and good name of the borough. Clahan tried to appoint state Republican Party chairman Edmund W. Wakelco as borough counsel, but the borough council refused to confirm the appointment. The council also refused to reappoint borough engineer Watson G. Clark and ordered him to appear before the council to "show cause why he should not be dismissed." Despite these troubles, Clahan completed his term.

Henry Wissel has been Edgewater's longest serving mayor, holding the office from January 1, 1914, to February 23, 1927, and then again from January 1, 1936, to December 31, 1953. His first term ended in 1927, when he resigned upon being sentenced to jail for a year and a day for conspiracy to violate the customs law in a liquor smuggling case during Prohibition. He was convicted along with police chief James A. Dinan and two Edgewater policemen. But all were later acquitted.

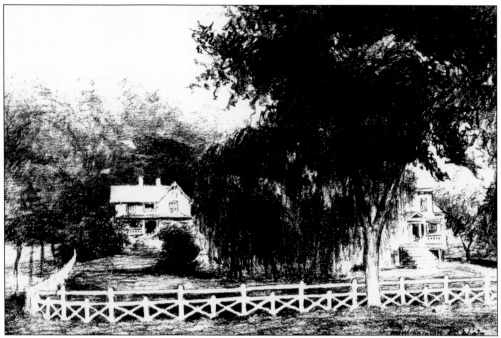

The first home of Henry Wissel was at the corner of Archer Avenue and River Road. He sold it to Archer Daniels Midland as a site for a flax oil processing plant and then moved to a home on Hilliard and Undercliff Avenues. The Midland plant is now the Octagon Processing plant, which is slated for demolition to make way for apartment houses.

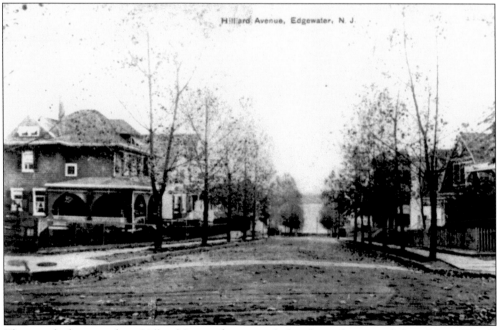

This view, looking east down Hilliard Avenue from a time before the road was paved, shows Henry Wissel's house on the left. The house was recently razed to make way for several town houses.

Mayor Henry Wissel speaks at a political rally, making a point about a newspaper story regarding a probe of riverfront operations. The paper in the mayor's hand is the *Hudson Dispatch*, now defunct.

When Henry Wissel resigned on February 23, 1927, John F. Dinan was installed as mayor and served until Wissel returned to office on January 1, 1936. Dinan was indicted on June 11, 1935, charged with liquor law violations and violation of the Internal Revenue Act. The charges were based on an April 16, 1934, raid by federal agents on a large distillery located in the old Higgins Dye Works, which adjoined a garage at 380 River Road, where Dinan operated a trucking business. According to federal agents, the distillery was connected to the garage by a door and was heated by Dinan's oil burner. Among the charges against the mayor were possession of a 12,350-gallon still, 13,275 gallons of liquor, and 265,000 gallons of mash. Dinan was the brother of police chief James A. Dinan, who was indicted and later cleared of rumrunning along with Mayor Henry Wissel. Mayor Dinan was defeated in a bid for reelection by Wissel, a Republican, who made a comeback with the support of both Republicans and Democrats. Dinan was cleared of all charges on April 23, 1936, when a federal judge ruled there was insufficient evidence against him. He died on January 30, 1953.

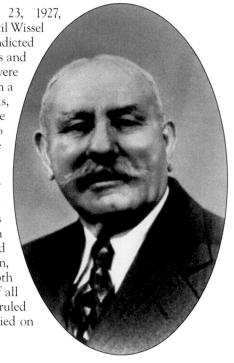

Milton T. Lasher began his term as mayor on January 1, 1954, following the long career of Mayor Henry Wissel. Lasher had made his reputation as a borough attorney in 1948, when he took steps to rid the town's riverfront of a colony of barge dwellers. At that time, he promised to "resort to fire or dynamite if necessary." (See pages 114–115.) He served until December 31, 1955.

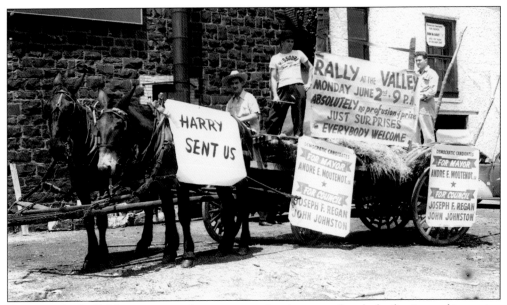

Democrat Andre E. Moutenot never became mayor, but it was not for a lack of trying and inventive campaigning. His running mate, James E. Regan, was elected mayor in 1955. Standing at the back of the wagon is party worker James O'Neil. The "Harry," of course, was Pres. Harry Truman.

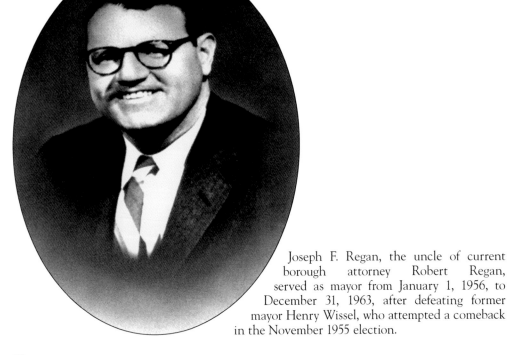

Joseph F. Regan, the uncle of current borough attorney Robert Regan, served as mayor from January 1, 1956, to December 31, 1963, after defeating former mayor Henry Wissel, who attempted a comeback in the November 1955 election.

DEMOCRATS!
UNDECLARED VOTERS!
Vote this Ticket
PRIMARY DAY
TUESDAY, JUNE 3rd, 1947

For Mayor

For Council

For Council

Andre Moutenot

RECOGNIZED
DEMOCRATS

John Johnston

Joseph Regan

MACHINES are GOOD for Industry
PRESSURE is GOOD for Cooking
BUT
BOTH are BAD for Good Government
STOP THE MACHINE STOP THE PRESSURE
VOTE FOR RECOGNIZED DEMOCRATS

Rally at the Valley - 9:30 preceded by car parade from top of Ft. Lee
Hill at 7:00-Bring a car, bring a friend. No profusion of prizes
JUST SURPRISES!

3 Paid for by Democratic Campaign Committee

The Democratic ticket of 1947 included future mayor Joseph Regan.

Mayor Joseph Regan hands a check over to the Edgewater Community Chest in 1962.

Edward J. Gilbarte was mayor from January 1, 1964, to December 31, 1965. He was a banker with a background in Hudson County.

John J. "Jack" Ferrie was mayor from January 1, 1966, to December 31, 1967.

Francis P. Meehan was mayor from January 1, 1968, to December 31, 1979. He was the last Republican to serve as mayor. One of 11 children, he came from a politically active family. His father served on the board of education, and both parents switched from the Democratic to the Republican party because they disapproved of Franklin Roosevelt seeking a fourth term as president. When Francis Meehan ran for reelection in 1975 at age 41, two younger brothers were also on the ballot, William C., aged 38, seeking a borough council seat in River Edge, and Dennis M., running for the state assembly. His brothers lost, but he defeated Arnold Hanusek 1,245 to 907.

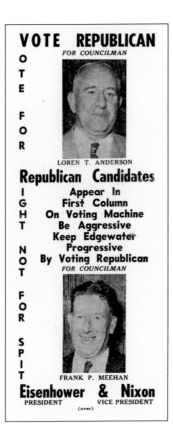

Francis Meehan was running for a borough council seat with Loren T. Anderson when this campaign literature was distributed.

Thomas J. Tansey was mayor from January 1, 1980, until November 17, 1987. He resigned his office to become borough clerk in 1987. His tenure marked the beginning of what would be a major redevelopment of the borough.

Bryan Christiansen moved from his borough council seat to become mayor on November 17, 1987, succeeding Thomas Tansey. He was subsequently elected in 1988 and served until January 1, 2004. His 16 years as mayor were marked by dramatic changes in the borough, as Edgewater made a transition from industrial sites that were mostly abandoned to tony upscale riverfront property of town houses, condominium communities, and new shopping developments. Major changes during the Christiansen administration were the demolition of the Alcoa plant and the straightening, realignment, and widening of River Road from Route 5 south to the Bergen county line.

Mayor Nancy Merse took office on January 1, 2004. She is the first woman to hold this office.

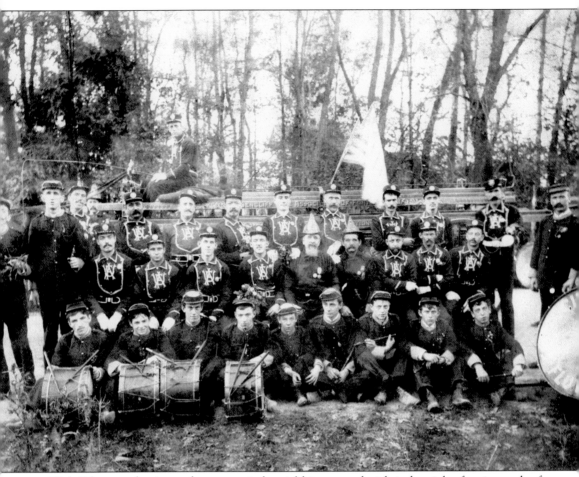

With Edgewater having such a strong industrial history, and with industrial safety in much of the last century not always up to today's standards, Edgewater's firemen in years past often faced difficult fires to extinguish. Unlike today's volunteer department, Edgewater once had a paid, full-time firefighting staff, which it could afford through the taxes paid by its numerous industries. Some photographs of firefighters from several eras follow. The earliest firefighter photograph available shows the Undercliff Association drum and fife unit from the 1800s, when the town was known as Undercliff. Among the men is one named Godfrey, the third from the left.

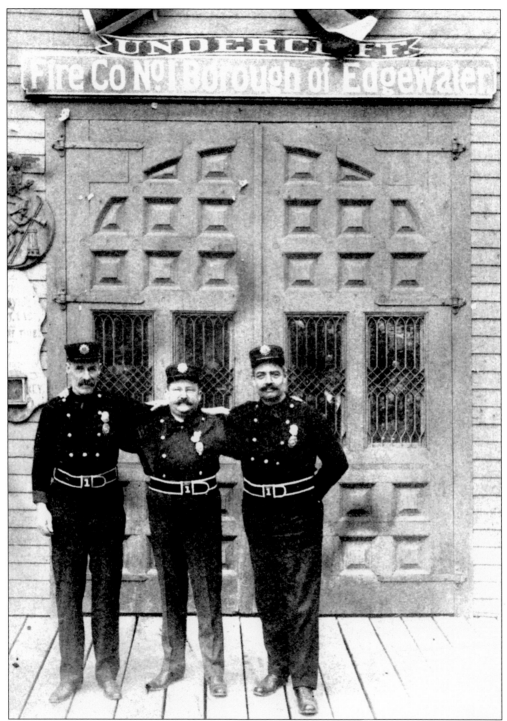

Three firefighters line up in front of the old firehouse for Company No. 1, in the north end of the borough on River Road, in the early 1900s. Note the sign over the door listing both Undercliff and Edgewater. Note the wooden plank sidewalk in front of the building. This firehouse was later replaced by the current building, located across from the colony.

MASS MEETING

of the CITIZENS of the
Borough of Edgewater N. J.

MONDAY EVENING
August 24th 1908

AT EDGEWATER CASINO

THE undersigned Citizens and Taxpayers of the Borough feeling that the sum of $14000 is an excessive amount to be expended for the construction of a fire-house and that before such an amount should be expended it should be left to a vote of its citizens to decide.

YOU SHOULD ATTEND THIS MEETING

If the Mayor and Council carry through this project it will mean an increase of tax upon the borough for the next five years of over $3,300 a year or the income from $200,000 of actual assessed valuation of property.

Opportunity will be given those desiring to be heard

(Signed)

J. CLAHAN, Jr. Pres. Borough Council
JOHN R. TOWLE, Sec'y, Board of Health
J. J. McGARRY, Rep. County Committeeman
CHARLES TUITE, Councilman J. CLAHAN Sr.
THOMAS BURNS, Councilman FRED CAMPBELL
LAWRENCE BUCKLEY, Recorder RALPH REED
THOMAS McLOUGHLIN

The Underwood Press, Edgewater, N. J.

This handbill was used to generate public support to replace the old Company No. 1 firehouse.

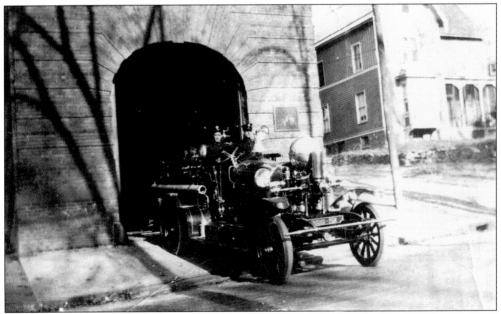

A vintage Ahrens Fox fire engine rolls out of Company No. 1's new firehouse, at 1408 River Road at the corner of Palisade Terrace. The house at the right has since been razed to make room for a parking lot for the River Palm Café.

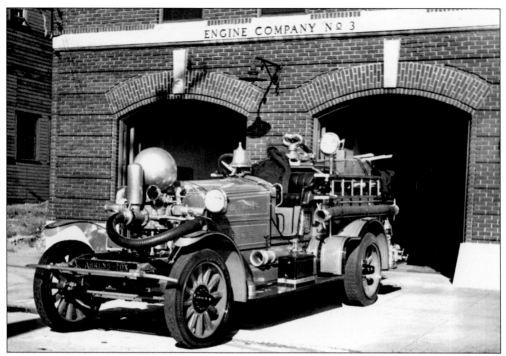

A fire engine from the 1920s is on display in front of Engine Company No. 3. Note the solid rubber tires. This firehouse in Shadyside is no longer used by the fire department but is a Veterans of Foreign Wars hall and is also used by the department of public works.

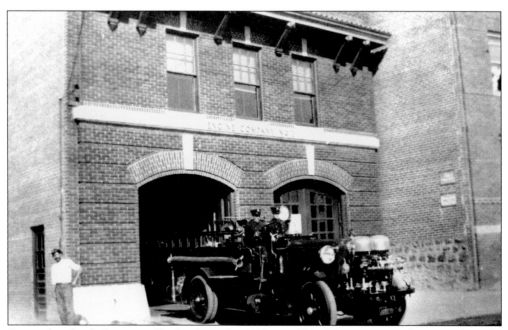

Pictured is the firehouse in Shadyside in the 1920s or 1930s. The apartment house to the right no longer exists.

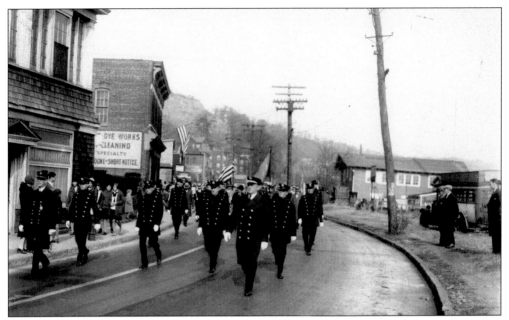

The fire department marches along River Road in the Armistice Day parade of 1929.

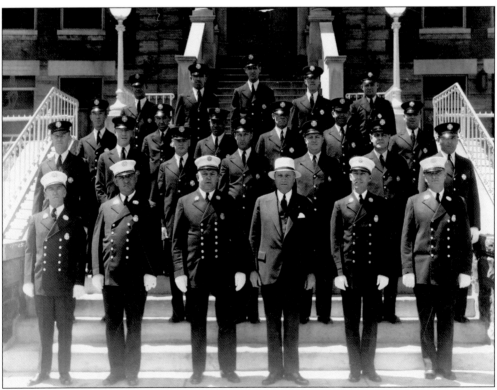

Decked out in their parade dress uniforms, members of the fire department line up in front of borough hall in a photograph from the 1930s or 1940s. At the front left is Capt. Frank Murphy, and third from the left is Chief George Lasher.

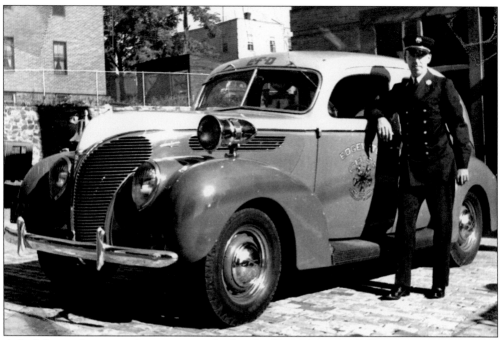

A firefighter takes a proud pose next to the fire chief's car from the 1930s.

Firefighters used to train regularly behind borough hall. Here they practice catching someone jumping into a net. They now train at a fire school in Mahwah, conducted by the county.

Ready for the next fire are Tom Reith, in the fire engine, and Al Scullion, standing next to it. This late-1950s photograph shows the interior of the fire department bays in the south side of borough hall. The department recently vacated this space to move to new facilities several blocks south of borough hall on River Road.

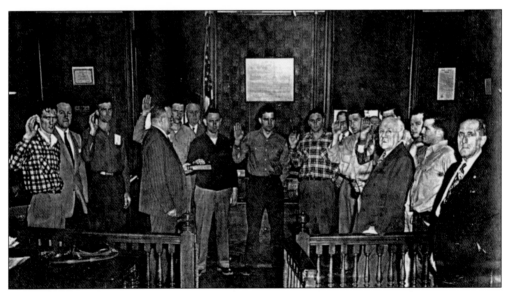

On January 2, 1952, Mayor Henry Wissel made good on a promise he had made to war veterans to provide jobs for them when they returned to civilian life. Wissel is at far right, as fire chief George Lasher swears in a group of new firemen, from left to right, Michael Reith, Luke Higgins, Anthony Griffin Jr., Donald Appleton, John Mrazek, James Murray, George Haefner, Richard Gaul, Charles Schiess, Joseph LaMarco, Peter F. O'Brien, Arthur Higgins, and Lawrence Merse.

Five

NEIGHBORHOODS

Tucked away on quiet residential streets—many of them in the north end of town, running off from the lengthy Undercliff Avenue, which runs from one end of the town to the other—are the residential streets where, until recent years, most of the people of Edgewater lived. Now, a good number of residents live on the river in condominiums and rental apartments and town houses on land that was once the province of heavy industry. Some see this as the creation of a town divided, with the newcomers living on the east side of River Road by the Hudson River and the old-timers living on the west side of River Road. Some of the old houses have been cut up into small apartments by absentee landlords, but some of the fine old houses remain intact. It is in these neighborhoods that one finds the two churches of Edgewater, its public school, and its library.

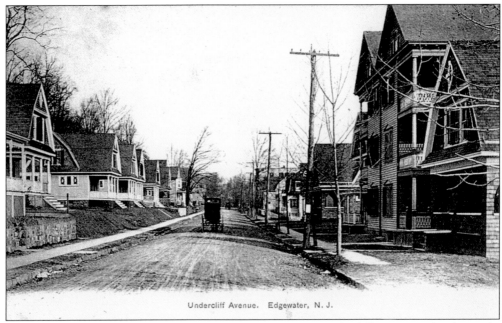

Undercliff Avenue. Edgewater, N. J.

A horse-drawn carriage ambles down an otherwise deserted Undercliff Avenue. This late-19th-century view indicates that Undercliff, like many of Edgewater's streets at that time, was unpaved.

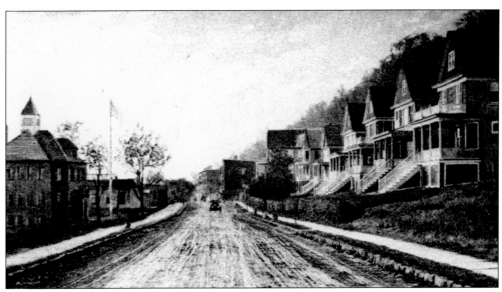

This view of Undercliff Avenue looks south near Garden Place. The current school, Eleanor Van Gelder School, now stands where this earlier school was located—on the left (east side) of Undercliff. The school is named for possibly the most important educator the borough has ever had. Born in Brooklyn, Eleanor Van Gelder came to Edgewater at the age of 17 and was hired to teach the town's children at the monthly salary of $30. She became principal in 1895. The school was named in her honor in 1931. She died on June 16, 1947, at age 84 at her home, at 170 Undercliff Avenue, opposite her school. At that point she had lived in Edgewater for 50 years, and her obituary stated that most of the present adult population in Edgewater had come under her influence.

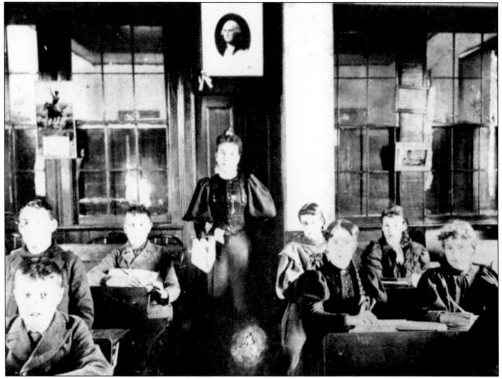

The town's best-known teacher, Eleanor Van Gelder, stands at the back of her class in a photograph that was probably taken in the 1890s. Sitting in the last row to the left of his teacher is Henry Wissel, who in 1914 became mayor.

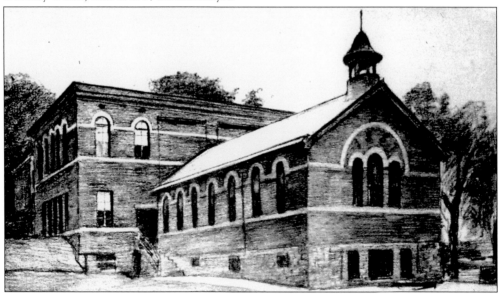

This is one of the town's schools, depending on which picture or drawing is being viewed, either School No. 3 or Washington School, which consisted of a small 1887 schoolhouse sitting in front of a large more recent addition at the rear. The earliest school was opened in 1798. According to some reports, there were once five schools in Edgewater.

Older residents who attended local school may remember school superintendent Dr. William Conway, who joined the school system in 1907 and rose to principal and then to superintendent. The family was active in the Church of the Holy Rosary, with his wife, Helen, serving as church organist. The Conways' son died in World War II, and their daughter became a nun.

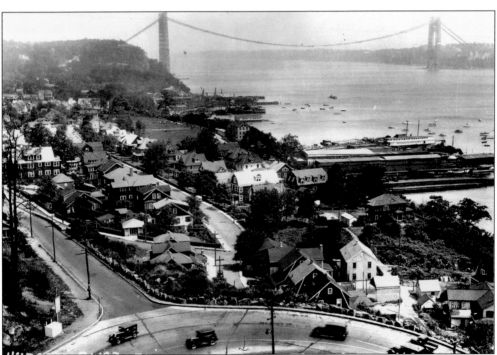

This photograph, taken above the hairpin curve on Route 5, gives an overview of the northern end of Edgewater. Running northward from Route 5 is the northern portion of Undercliff Avenue. The next street to the right is Myrtle Avenue, which for a few blocks parallels Undercliff. Closer to the Hudson River at the right is River Road, but it cannot be readily discerned. In the distance, spanning the river, is the then brand-new George Washington Bridge, which opened in 1931.

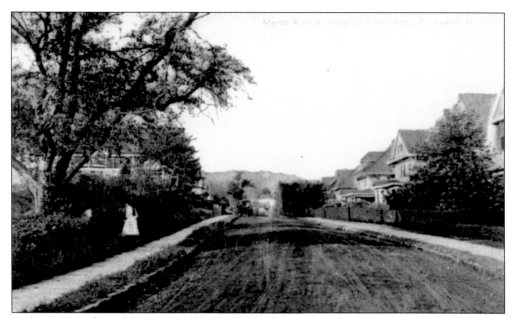

A closer view of Myrtle Avenue is shown in this photo postcard.

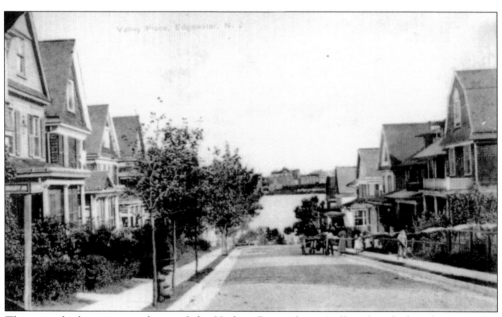

This view, looking eastward toward the Hudson River, shows Valley Place before the river view was obstructed by construction of the Admiral's Walk apartment complex.

A WPA sketch from the 1930s, looking southward, shows an Edgewater Place that has a residential character, in contrast to the industry that occupied most of the east side of the street some 20 years earlier. Missing from the view is the store with apartments above it that is now located on the left (southeast) corner of Edgewater and Hilliard Avenue.

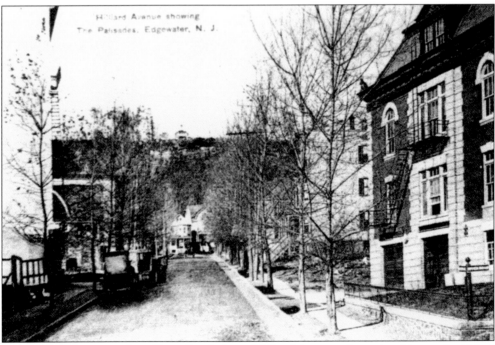

This view, looking west from River Road, shows Hilliard Avenue. A portion (the south side) of borough hall can be seen at the right.

The town was historically largely Catholic, and its principal church was the Church of the Holy Rosary, located on Undercliff Avenue, a long block north of Garden Place. Constructed in 1907, the church was dedicated at services on November 24, 1907. The first construction was the building that is now the church hall, with its entrance on Edgewater Place. The church is the home to a parish that first conducted mass in Taylor's Hotel and then in borough hall. The first mass was conducted in 1906. The first priest to lead Holy Rosary was the Reverend David J. Brady.

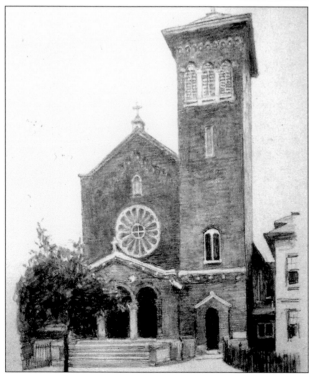

This view of the Church of the Holy Rosary is a sketch done as part of a WPA project.

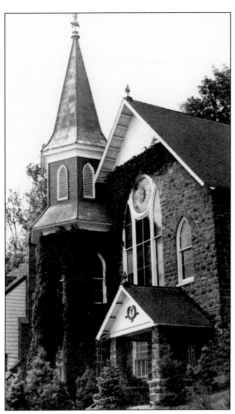

The First Presbyterian Church of Edgewater is at the northern end of Undercliff Avenue, across from Sterling Place. This house of worship was not always a Presbyterian church, and it took a great deal of wrangling and controversy before it became Presbyterian. The church began as a union church—a facility that was available jointly to more than one denomination. Trouble developed when Presbyterians among the worshipers decided the church should no longer be a union church but a Presbyterian church. With five members on the church board of trustees, all Presbyterians, the plan moved forward, but these elders did not count on a revolt from the Sunday school and its students (see page 109).

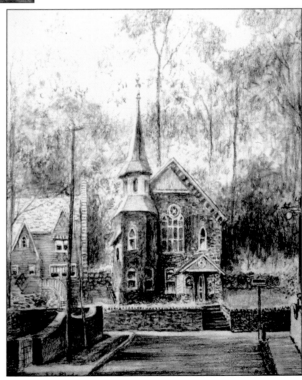

Here is another view of the First Presbyterian Church, a WPA sketch.

The Palisade Post

GRANTWOOD, N. J., MAY 14, 1909.　　　　PRICE 2

FACTIONAL WELFARE SPLITS
EDGEWATER'S UNION CHURCH

LOCKS AND BARS AND A STALWART POLICEMAN GIVE SENSATIONAL SETTING TO THE CONTROVERSY.

SUPT. ROBBINS IS BARRED FROM BUILDING

TRUSTEES ISSUE A CONCISE STATEMENT SETTING FORTH THEIR SIDE OF THE CASE.

ROBBINS MAKES BITTER ORAL DENUNCIATION.

CHURCH AROUND WHICH THE BATTLE RAGES.

The front page of the May 14, 1909, *Palisade Post* tells the story with the banner headline "Factional Warfare splits Edgewater Union Church." The *New York Times* also covered the schism, reporting on May 10, 1909, that feelings were running so high that John W. Watkins, who donated the land for the church, was going to consult a lawyer to see if he could rescind his donation. The *Times* reported on the following confrontation in front of the church between the church's trustee president Lynn M. Saxton, a Presbyterian, and Watkins, the undenominational Sunday school superintendent, along with his 80 Sunday school students. With Watkins were eight Sunday school teachers, including his married daughter, Mrs. W. H. Lawson. After Saxton said that the children, but not Watkins, could enter, Mrs. Lawson polled the children and all agreed to go to her house, a few blocks away, for their Sunday school lessons.

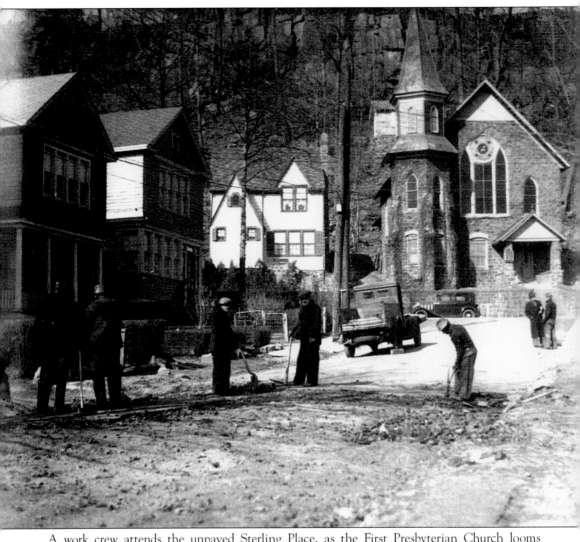

A work crew attends the unpaved Sterling Place, as the First Presbyterian Church looms on Undercliff Avenue.

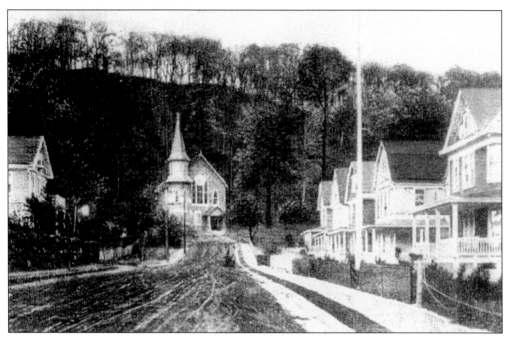

This view shows a greater portion of Sterling Place and its houses, with the First Presbyterian Church in view on Undercliff Avenue.

The beginnings of the Episcopal Church of the Mediator can be found in the formation of the Society of Christians in 1855, who recognized a need for a place of worship. The church began as a union church, with the Episcopalians conducting services on Sunday morning and the Dutch Reformed holding services on Sunday afternoon. Land was donated by the Vreeland family at River Road and Vreeland Terrace. Shown is the church as it once appeared at that location. This church was founded in 1857, and by 1862, the Episcopalians had full control of the edifice. The congregation moved to Hudson Avenue and Annette Place in 1915, where a stone congregational meeting room was constructed. There were plans for a church to be built in the future, but this never happened. The church eventually faced a diminished membership and dissolved. On February 3, 1927, the Associated Press reported that the Reverend E. Albert Phillips, who was the preacher at services attended by Pres. Calvin Coolidge and his wife at Plymouth, Vermont, in August 1926, resigned as pastor of St. Luke's Episcopal Church in Paterson to become rector of the Church of the Mediator. Today, the old church building is a Montessori school.

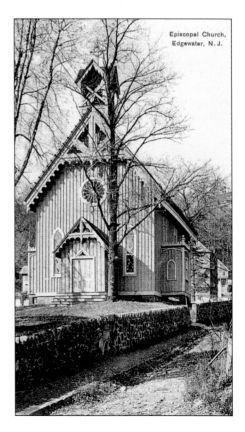

Episcopal Church, Edgewater, N. J.

Edgewater Free Library, Edgewater, N. J.

Pictured is the Edgewater Free Public Library as it looked around 1920. The library is an Andrew Carnegie Library, constructed in 1916. It is the last Carnegie Library still stranding in Bergen County and the last of 15 in the state and an estimated 1,300 in the nation. Located on the northeast corner of Undercliff and Hudson Avenues, the library was built on four building lots sold to the town by W. O. Ross at a discounted rate of $800 for land that was valued at that time at $4,800. One of the requirements that had to be met for Carnegie to donate the funds for the library was that the town had to dedicate an annual amount collected in taxes equal to 10 percent of the Carnegie grant to insure operating funds for the library.

Longtime librarian Anna "Nancy" Bowman is fondly remembered by many residents, particularly adults, who recall her reading to them when they were children. She was with the library for 25 years from 1927 to 1962. For 19 of those years, she was the library director.

Six

STORIES WORTH RETELLING

Through the years, there have been varied and interesting happenings in Edgewater that have gained widespread attention. For example, robbers broke the hearts of dog lovers in 1911 and gave the town a bad name for a time when, according to the *New York Times* of January 3, 1911, "nearly every dog in Edgewater was poisoned." The robbers soon showed up and attempted to hold up the Strickland McCay's store and broke into the railroad station and post office. They blew open a safe but got little for their trouble. The station agent was prepared after the dogs were poisoned and kept little money on hand. "Three rough-looking men fled from McCay's when help came in sight," the *Times* reported.

Under the headline "Gland Cure Ordered for School's Bad Boy," the *New York Times* reported that the Edgewater Board of Education on September 25, 1930, passed a resolution authorizing school physician Dr. James Buckley to proceed with "full power and authority, but without liability to the board to make normal a 12-year-old boy by means of treatment of the pituitary gland." The report continues that "the boy, who lives with his parents on a houseboat off Edgewater (see subsequent story) has at various times threatened his teacher with violence, rubbed poison ivy on the faces of other children and threatened his schoolmates with a large jack-knife, according to reports made to the school board by teachers and pupils." The resolution was the result of "repeated requests by Dr. Buckley, who has obtained the permission of the boy's parents. The board agreed to pay for the treatments, which are expected to take six months. In a previous effort to provide special disciplinary treatment, teachers took the boy to a Hackensack psychologist, but the results were reported to be 'not satisfactory.' "

BOATS, MAPS SEIZED AT A GERMAN CAMP

Craft Like Those Used by Nazi Troops Taken by FBI in Edgewater Raid

Special to THE NEW YORK TIMES.

EDGEWATER, N. J., May 30— Thirty collapsible rubber boats, maps of inland waterways, field glasses and arms and ammunition were seized in Edgewater early this morning by FBI agents and local police when they sprang up on the Edgewater Colony Association and apprehended an undisclosed number of German aliens and nationals.

E. E. Conroy, agent in charge of the FBI office in Newark, said the raid was the largest of its kind in the metropolitan area since the World War with the single exception of the raid last March 28 on the German Seamen's Home in Hoboken, when seventy-one persons suspected of being members of a spy ring were taken into custody.

Whole families of Germans, members of the Edgewater Colony Association, which was organized here some years ago as a boating club, occupied a fourth of about 130 cabins in O'Brien's Camp, a vacation resort nestled beneath a grove of trees on the bank of the Hudson River two and a half miles north of the 125th Street Ferry and at the foot of a wooded ravine bisecting the cliffs of the Palisades.

In recent months, Edgewater police noticed a "suspicious infiltration" into the membership of the association and notified the FBI, which began surveillance of the camp and its tenants. A comparatively brief period of observation, according to Mr. Conroy, convinced the FBI that the association should "be broken up before we'd be sorry."

Was it the home front hysteria of World War II or were Nazi agents really camped out in the Edgewater Colony on May 30, 1942? This *New York Times* first-page story tells the tale.

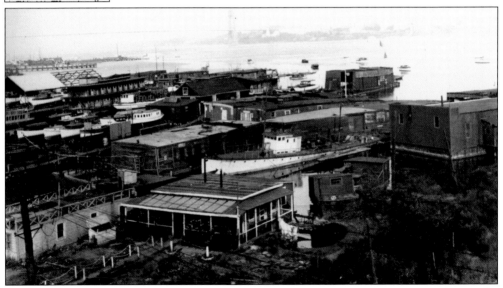

This jumble of architecture may seem to be on land, but most of what can be seen lies in the Hudson River. These are the tightly crammed together ramshackle collection of derelict and dilapidated houseboats, cabin cruisers, and barges with additional shanty structures. Sitting in mud flats that ran with raw sewage for lack of sanitary facilities, this expanse of nautical junk was home to hundreds of families for more than 50 years. Dr. William L. James, borough health officer, declared in 1933 the conditions on the assorted craft "a menace to health." At that point, it was estimated there were 200 barges accommodating these river dwellers.

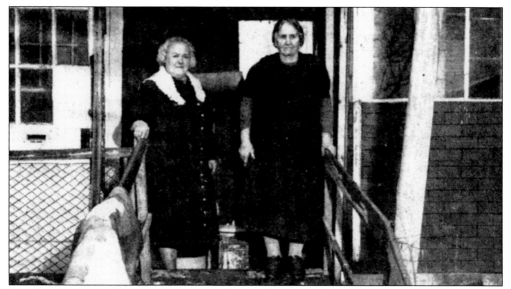

Conditions were no better 15 years later when Milton T. Lasher, borough attorney, took decisive action. Most of the families paid $15 a year for leases to sit within riparian rights held by Public Service Electric & Gas Company, which supplied electricity and gas to these families. Lasher struck at the heart of this arrangement, convincing Public Service to cancel the leases so the borough could declare the hovels uninhabitable and order them vacated. All but four families moved, and those four were given a brief extension before eviction proceedings began. Shown here are Olga Maria Pettila, right, and her daughter, Hildegarde Bergmann, who were among those evicted. When the last of the barge people left, the borough had the community burned. Later, the mud flats were built up with fill and the Admiral's Walk apartment complex was constructed there.

Edgewater Public Works worker Frank Ansell boards up the entrance to a houseboat from which Olga Maria Pettila, 77, her daughter, Hildegarde Bergmann, 41, and son, John Kasperson, 38, were evicted on November 3, the day before this photograph was taken. Notified in September that they would have to move, they were served with a writ of eviction several days before they were forced to leave the houseboat by Deputy Sheriff James I. Norton. Pettila claimed she owned the barge on which she had lived for 26 years.

MOVIE ACTOR SLAIN IN ROW OVER WIFE BY FILM DIRECTOR

John Bergen Shot to Death by George F. Cline in Latter's Home in Edgewater.

OFFERED TO FIGHT DUEL

Slayer Taxes Victim With Insulting Mrs. Cline and Hands Him a Pistol.

LATER TAKES WEAPON BACK

"George Cline Killed Me," Written on Piece of Paper Found in Dying Man's Pocket.

A domestic triangle in the moving picture world ended last night in the killing of John Bergen, a young moving picture actor. Bergen was shot and killed by George F. Cline, a moving picture director, in the latter's home in Edgewater. N. J., near the Fort Lee picture studios, while Mrs. Cline looked on.

Cline, who was immediately arrested on the charge of murder, told County Detective Nathan Allyn a remarkable story. He said that Bergen had attacked Mrs. Cline several weeks ago while all three were working on a picture for the Fox Film Corporation at Saranac Lake and that he and Bergen had quarreled over Mrs. Cline when Bergen went to Edgewater yesterday. According to Cline, he brought out two revolvers, gave one to Bergen, and called upon him to engage in a duel in the presence of Mrs. Cline and her two brothers. For some reason not explained in Cline's statement, the pistol battle was called off and he took the revolver away from Bergen. Later, Cline said, Bergen attacked him with a blackjack and he shot him in self-defense.

Slayer's Story Contradicted.

The story told by Cline had it that Bergen ran out of the house and fell dead in the street about a block away. Prosecutor A. C. Hart of Bergen County, in announcing that he would have Cline held for murder, pointed out that this part of Cline's story disagreed with the statements made by the Edgewater

BERGEN SHOT DOWN WITHOUT A CHANCE, SAYS GIRL WITNESS

Forced Tremblingly Up Stairway at Point of Cline's Gun, Says Alice Thornton.

BITTER QUARREL OVER WIFE

Actress Who Was in the House Tells How Husband Accused Actor of Wrecking Home.

NO MENTION OF A DUEL

Nor Was There Sound of a Struggle, She Declares—Corroborated by a Man Who Was There.

Two new witnesses made statements to the authorities last night that tend to contradict and disprove the story told by George F. Cline, Fox Films location man, to account for the killing of "Handsome Jack" Bergen, movie daredevil, in Cline's home at Edgewater, N. J., last Friday night.

Both of the new witnesses, a man and a woman, were in the house at the time of the shooting, but they absolutely deny that they saw or heard anything to indicate that a duel was fought or was to be fought, that Bergen had a pistol or any other weapon in his hand at any time, or that he had any chance for his life.

Another development convincing the prosecution that Bergen was murdered in cold blood was the discovery yesterday that a bullet hole in a door on the second floor of the Cline cottage slanted downward. The autopsy already had shown that the bullet had gone through the body, and the hole in the chest was considerably higher than the hole in the back.

The door struck by the bullet was not the door of the bedroom, where Cline said the duel was staged, but a door at the head of the stairs. From these circumstances, therefore, the prosecutor believes that Bergen was shot as he knelt and begged for his life, that he was shot from above, and that the bullet went downward through his body and downward through the door.

ALL THREE ACQUITTED IN BERGIN TRAGEDY

Jury With Six Woman Members Resents Dead Man's Slur on Womankind.

UPHOLDS "UNWRITTEN LAW"

Cline Returns to Wife, Whose Relations With Movie Actor Led to Shooting.

George Cline, Alice Thornton and Charles Scullion were all acquitted yesterday in Hackensack, N. J., of the charge of murdering Jack Bergin, a moving picture actor, who was shot in Cline's house in Edgewater, N. J., on Aug. 25.

The verdict was rather a surprise to some who heard Justice C. W. Parker's charge, in which he said that there was nothing presented to uphold the defense of either self-defense or justifiable homicide. He said that the evidence showed that Bergin was driven upstairs at the point of a revolver, which did not suggest self-defense, and that the only justification for homicide was when a man was roused to sudden passion by finding his wife in the arms of another. A considerable time intervened between the intimacy with Bergin to which Mrs. Cline confessed and the shooting.

One of the jurors after the acquittal said that the things which impressed the jurors, including the six women, more than anything else was Bergin's statement that "all women are bums," and his reference to Mrs. Cline as a "bum" when confronted with her confession by Cline.

"I have a wife and daughter, and what Bergin said impressed me and all of us," said one juror. And a woman juror said: "A man has a right to protect his home. My husband would have done the same thing under similar circumstances," while the comment of Miss Susan A. Squire, the 23-year-old forewoman, was ."We were convinced the prosecution failed to prove its case."

Scandal in the film world came to 190 Undercliff Avenue in a section behind the Alcoa plant, as a jealous husband shot and killed a man he believed was having an affair with his wife. After being acquitted of murder, George Cline went on to have a minor film career, appearing in at least two films low on the lists of players. His apparent first film was *Janice Meredith*, starring Marion Davies and a large cast that included Tyrone Power and W. C. Fields. The film, an epic about the American Revolution, was released on December 8, 1924. Cline played trooper Heinrich Bruner. His second film was *The Pinch Hitter*, starring Glen Hunter and Constance Bennett and released on December 13, 1925. Cline played the role of coach Nolan in this tale of a student who saves the day for his college baseball team. Not too much is known of Bergen, or Bergin (the spelling of his name changed during the coverage of the trial), a vaudevillian who broke into the movies as a stunt man, who in the end was portrayed as a cad, and a rather coarse one.

116

Seven

INTERESTING PEOPLE OF NOTE

For the size of the town, Edgewater has had some interesting people of various accomplishments, and some predicaments.

Dr. John Ellis, who headed the Ellis Oil Refining Works at Edgewater, left at his death on December 2, 1896, an estate of $250,000—much of it to the American Swedenborg Society to print, bind, and distribute to all clergymen (asking for it) the first volume of Swedenborg's *Arcana Celestia* and $10,000 to make translations of Swedenborg's works for distribution among Swedes in Italy and the United States.

E. O. Chamberlin, managing editor of the *Evening World*, made news himself. The *New York Times,* on March 15, 1898, reported that he "Has Brain Fever from Overwork" and published the following account: "Ernest O. Chamberlin, is lying at his home, at Edgewater, N.J. suffering from a severe attack of brain fever, said to have been caused by overwork in the discharge of his editorial duties. The numerous daily editions of the paper since the *Maine* disaster (the sinking of the U.S.S. *Maine* in Cuba, which set off the Spanish-American War) giving the different phases and developments of the war scare, have called for the almost unremitting attention of Mr. Chamberlin. It was known that he was wearing out his strength by remaining at his desk not only during the day, but a great part of the night. His associates realizing that he was seriously ill prevailed upon him to go home. On Sunday morning, he returned to the office and ordered a page of war news to be cabled from London. Joseph Pulitzer, the proprietor of *The World*, was notified and he promptly gave Mr. Chamberlin $500 and preemptorily ordered him away from the office on a month's vacation. He returned to his home and his illness developed into brain fever. Mr. Chamberlin's physicians held out hopes for his recovery."

In 1910, Frank Goodlae, starting off to carry a message of welcome to Pres. Theodore Roosevelt, who was aboard the ship *Kaiserin Auguste Victoria* then entering New York bay, did not make it, as his dirigible balloon was wrecked during takeoff at Edgewater.

Erne J. Riley, whom the *New York Times* described as a cripple since infancy, was a poet of enough talent that her poems were read over the radio. She died in November 1928 in her bed at the age of 32 in a house fire, while her parents were attending services at the First Presbyterian Church, only a few blocks away from the Riley home, at 11 Myrtle Avenue.

On February 17, 1929, the *New York Times* did an interview with C. C. Blakeley, whose colorful life of 87 years was told to a *Times* reporter at his Edgewater home. He told of the violence

against the "drys" from the local saloon owners in Calhoun County, Michigan, where he grew up, and his later years in New York, where he played baseball when no one wore gloves, and how he became acquainted with prize fighter John L. Sullivan and Pres. Theodore Roosevelt. He also told of a buffalo-hunting trip with the Prince of Wales in Iowa and how the Prince of Wales introduced the style of creases in men's trousers.

Arthur Townsend was born in Edgewater and made his name in New York, where he founded the law firm of Townsend, Kidleberger & Campbell in 1920. As a resident of Montclair, he became president of the Montclair Art Museum. He and his wife lived in France for four years but returned to the United States via Lisbon after living for a time under German occupation in 1940. He died at the age of 73 shortly after returning to America on November 8, 1940.

Among those giving blood to the Northern Valley Red Cross Blood Bank at the Edgewater Alcoa plant on May 16, 1945, was Sgt. Howard Harper, 25, a discharged wounded veteran, who called his donation a "return," recalling that he was given three pints of blood when he was wounded in Europe. Harper was much decorated during his service, being awarded the Purple Heart, the Distinguished Flying Cross, the Air Medal with four oak-leaf clusters, and a presidential unit citation. He was taken prisoner once but escaped with the aid of the French underground.

Robert Chestnut of Edgewater was elected president of the National Screw Machine Products Association on April 1, 1948, at its convention in Chicago, the *New York Times* reported.

Charles R. Tuite was a public-spirited resident of Edgewater. For 15 years, until he died in January 1938, he was secretary of the board of health. He was also a borough councilman, a volunteer firefighter, and veteran of the Spanish-American War.

More stories follow.

Possibly the most famous celebrity from Edgewater is Go-Wan-Go Mohawk, an American Indian who was both an actress and a playwright, best known to the residents of Edgewater as a fixture in local parades, riding her horse Becky. She was reportedly an Indian princess, the daughter of chief and medicine man Dr. Alan Mohawk, who lived in Greene, New York, and who built a cabin that he named for his daughter. Go-Wan-Go, or Go-Won-Go, means "I fear no one." Dr. Mohawk made house calls with his horse and wagon. He wore a small saw strapped to one of his legs for surgery. On January 18, 1903, his daughter was starring in her own play *The Flaming Arrow* at the Third Avenue Theater in Manhattan. The production was apparently doing well enough that a $100 donation to the Actor's Sanitarium Fund was made by the Flaming Arrow Company in May 1903.

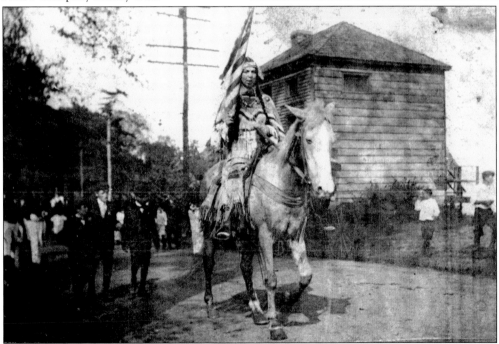

Go-Wan-Go Mohawk rides her horse down River Road past the colony area toward the center of town in a 1905 parade. She was married to a former army captain, Charles W. Charles, who served with General Custer in the West. The couple lived at 764 Undercliff Avenue. She died in 1924 at age 58. She is buried in the Edgewater Cemetery, as is her husband, who died two years after her. In 1905, she was in St. Helens, near Liverpool in England, starring in her own play *Wep-ton-No-Mah, the Indian Mail Carrier*. In 1909, a film by the same name, was produced by the Carson studios. There is no information available about this film, which may have starred Mohawk.

This cloth or table napkin was perhaps a souvenir of a party or notable gathering. However the two dates (1901 and 1903) indicate the signatures were collected over time. It was signed by Go-Wan-Go, Ethel Barrymore, and Eddie Foy Jr., which might indicate the level of acquaintances she had in show business. The signatures were later embroidered to preserve their legibility. Go-wan-go had the reputation of signing her autograph as "Aboriginaly yours," but that is not the case here.

This sculpture was created by Lindsey Morris Sterling, who was living at 3 Oak Wood Road when she died at age 54 in July 1931. Born in Perth Amboy on November 8, 1876, she worked as an illustrator and staff artist at the American Museum of Natural History in New York City for 30 years, beginning in 1901 under Henry Fairfield Osborn in the Department of Vertebrate Paleontology. She studied sculpture in Paris, and her best work is said to be in bas reliefs and small bronzes. She often exhibited at the Architectural League and the National Academy, and occasionally at the Pennsylvania Academy of Fine Arts and in St. Louis. Her work is sought by collectors today. After her death, her mother, Ella B. Morris, established the Lindsey Morris Sterling prize for an art competition.

GAY MOURNS LOSS OF HIS AIRSHIP

Asks Ship Captains to Look Out for Dismantled Craft Which Carried Him Into the Sound.

THE TRIP DIDN'T SCARE HIM

But He Would Have Been Drowned if Motor Boat Had Not Put Out to Him Quickly.

George M. Gay, the young aeronaut, who was carried over the Palisades, across this city, and into the Sound on Saturday night in a dismantled airship, arrived at his home in Edgewater, N. J., at 2:30 o'clock yesterday morning none the worse for his thrilling adventure.

There was nothing in his manner to indicate that he considered his long ride in the airship without either rudder or motive power particularly dangerous. His chief sorrow was that he had lost the airship. He tried to comfort himself with the thought that it had notable precedents for its end in the fate of Vaniman's and Wellman's airships, but all day he inquired anxiously for word of it, and finally sent a wireless message asking Captains to look out for the craft.

Gay discovered that it took him two hours longer to make his way back from Sands Point, where he dropped from his runaway airship into the Sound, than it required for him to go there through the air.

Edgewater resident George M. Gay was off on a daring exploit on July 7, 1913.

121

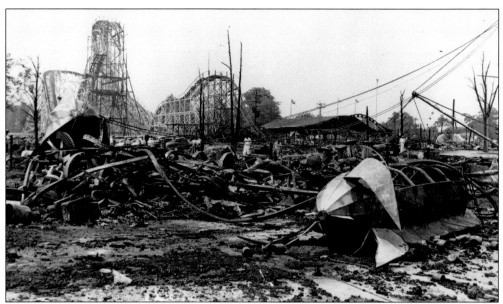

On August 13, 1944, Palisades Amusement Park, which looked down on Edgewater from the edge of the Palisades in Cliffside Park and Fort Lee, went up in flames. Six died, and more than 100 suffered burns and were injured. Marguerite Bailey, 30, a registered nurse, heard an appeal for help on the radio in her home at 615 Undercliff Avenue. She responded, going up the hill to the amusement park, where she worked for hours treating 75 people for burns, smoke inhalation, and heat exhaustion. The photograph shows the wreckage after the fire was out. In the foreground is a "rocket" that carried riders high above the crowd in a merry-go-round fashion. In the distance, the frame for the roller coaster still stands.

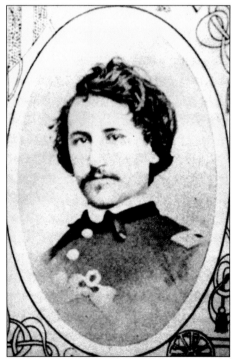

Capt. Augustus M. Wright of the 57th Regiment of New York Volunteers fought in the Civil War. In the battle of Petersburg, in June 1863, he was shot in the leg. His leg was amputated, and he died a month later in Washington, D.C. Due to the fact that he had friends in Edgewater, he was buried in the Edgewater Cemetery. Among his friends was Charles S. Watkins, who built the first free school where the George Washington School now stands on River Road. He is the subject of a book by Edgewater Cultural & Historical Committee member Ruth Paci. Its title: *Dear Friends, a Civil War Soldier writes to Edgewater, N.J.*

Eight

SPORTS AND LEISURE

Over the years, residents have taken up and often excelled in a variety of activities, including boating, motoring, dog shows, horse races, and knitting.

Before industry took over Edgewater's riverfront, boating activities and competitive races were common on the Hudson River, involving everything from canoes to rowing shells to powerboats. There was a time that the manufacture of shells—long boats that take a team of oarsmen to row them in competitions that are popular at Ivy League schools—was a major activity along the river front of Edgewater. In fact, the *New York Times* reported in 1916 that the Al Ward boathouse in Edgewater was the principal plant in the country for the construction of shells.

The Active Boat Club of Edgewater traveled to major competitions such as the People's Day Regatta on the Schuykill River in eastern Pennsylvania in 1926. Motorboats were popular in Edgewater, too. On June 2, 1935, a total of 20 new motorboats completed the annual long-distance cruise from Tonawanda, New York, to the Undercliff Boat Works in Edgewater. Harold June, chief pilot of the Byrd expedition, joined the flotilla up the Hudson to finish the cruise and have a part in the Edgewater reception.

Many of these riverfront clubs survived the crowding of piers of heavy industry. It was a land sale with 1,100-foot frontage on the river and on River Road that doomed much of the club's activities. When Public Service Electric & Gas put this property up for sale, they gave notice in the spring of 1960 to the Undercliff Boatworks, the Wanda Canoe Club, the Undercliff Motor Boat Club, the Active Motor Boat Club, and Castellano's Edgewater Marine to be prepared to vacate this property on 30 to 60 days' notice.

With the advent of automobiles, the hills leading out of Edgewater up the Palisades to the west were a challenge for motorists and their vehicles to climb. Not content with local hills, Mr. and Mrs. John H. Hinners of Edgewater journeyed to Woodstock, New York, in 1910 with one of the few cars capable of climbing Overlook Mountain. Also in 1910, the Catskill Reliability Contest route was laid out from Edgewater to the Catskills, along the west bank of the Hudson River, with a return trip via Newburg and Suffern, New York, back to Edgewater.

In addition to these activities, other residents excelled in unique leisure pastimes. One woman showed a champion dog. Another won a knitting bee. Another woman won a horse race to raise funds for her church.

Clifford Sweet William, an Old English sheepdog owned by Laura Dohring of Edgewater, won Best in Show in a field of 120 dogs at the first annual exhibit of the Richmond County Fair on September 9, 1926. Two years later, on November 28, 1928, Dohring's dog Champion Minstrel Boy, another Old English sheepdog, won Best in Show at the International Dog Show in conjunction with the Royal Agricultural Winter Fair in Toronto.

In a knitting bee competition held on the Mall in Central Park, New York, on August 2, 1918, Helen Williams won first prize for being the fastest knitter of socks.

May Clahan, a sister of former freeholder John Clahan on August 30, 1909, drove a roan pacer by the name of Yankee Boy to victory at a special race in Guttenberg attended by some 5,000 racing fans. The race was a fund-raiser for Edgewater's Church of the Rosary, of which May Clahan was a member. A *New York Times* story reported that Clahan "handled the reins expertly and kept her horse at a good pace." The report continues that she came "under the wire a length to the good." Four years earlier, a team of black pacers from Edgewater competed at the Harlem River Speedway, according to a report in the *New York Times*. Neither the rider nor the owner was identified.

Another prominent trainer and owner of racehorses was Charles L. Carroll from Edgewater, who died May 5, 1939, of a heart attack at Jamaica Race Track on Long Island at the age of 70, an hour before his horse Rosarian, a five-year-old, won the first race of the day.

Trap shooting was popular at the North River Gun Club in Edgewater in 1907. Trophies were awarded, and the results were regularly published in the newspapers.

Several professional boxers called Edgewater home, and one of Notre Dame's best football players grew up in Edgewater in the 1930s. Jim "Superman" White was one of the finest tackles Frank Leahy had at Notre Dame in the 1940s. White was instrumental in leading the Fighting Irish to a national championship in 1943, a season that included Notre Dame beating Army 26-0. It is said that White helped his quarterback Angelo Bertelli win the Heisman Trophy that year. White was recognized for his play, finishing ninth in the Heisman vote. In 1946, at the age of 25, he was signed by the New York Football Giants, shortly after his discharge from the navy. He joined the navy in late 1943 and served in the Pacific. He prepped for Notre Dame at All Hallows School, where he starred in football and was a 220-yard and quarter-mile champion.

Wanda Canoe Club Trophy
==================
DONATED BY
THE MEMBERSHIP 1922

(Back of Cup) (The Cup)

CHARLES KRAUS		1922
ERNEST F. BAUMANN		1923
EDWARD WICHSER		1924
JOHN E. KUHNAST		1929
JOHN F. KUHNAST		1930
DAVID S. FISHMAN		1931
EDWARD BEBUS		1932
JOHN RYAN	}	1933
CHARLES NORMAN	}	
JOHN RYAN		1934
WM. A. FRANZ		1935
WM. A. FRANZ		1936
JOHN RYAN		1937
JOHN RYAN		1938
JOHN RYAN		1939
AUGUST STRITT		1940

(Plate on Front of Base)

CHARLES NORMAN	1941	ROBERT GUYRE	1960	PETR TOLAR	1971	
AUGUST STRITT	1946	MIRO KOLPAK	1963	PETR TOLAR	1972	
H. MESSERSCHMIDT, JR	1953	PAUL GUYRE	1964	PETR TOLAR	1973	
CHARLES NORMAN, JR	1954	RONALD GUYRE	1965	PETR TOLAR	1974	
N. MESSERSCHMIDT	1955	PAUL GUYRE	1966	WARREN YEISLEY	1975	
N. MESSERSCHMIDT	1956	PAUL GUYRE	1967	PETER ROSS	1976	
WM. VAN KEUREN	1957	LOUIS FERNANDEZ	1968	GILBERT ROSS	1977	
F. ROBERTS }	1958	LOUIS FERNANDEZ	1969	KEVIN DERMOND	1978	
H. WALLACK }		LOUIS FERNANDEZ	1970	KEVIN DERMOND	1979	
F. ROBERTS	1959			KEVIN DERMOND	1980	
				WILLIAM R. BRITT	1981	

(Plate on Back of Base)

WILLIAM R. BRITT	1982	JOHN ZEIGLER	1994
PETER KRILLA	1983	JOHN ZEIGLER	1995
WARREN YEISLEY	1984	JOHN ZEIGLER	1996
WARREN YEISLEY	1985	JOHN ZEIGLER	1997
WARREN YEISLEY	1986		
KEVIN DERMOND	1987		
WARREN YEISLEY	1988		
JOHN ZEIGLER	1989		
LARRY DECKER	1990		
JOHN PONTICORVO	1991		
JOHN PONTICORVO	1992		
JOHN PONTICORVO	1993		

The Wanda Canoe Club has annual competitions and a trophy to show the extent of its history. The club is no longer in Edgewater but has moved to Ridgefield Park, on the Hackensack River. The club has quite a history. The *New York Times* reported on October 8, 1936, that Commo. William T. Reiners of the Edgewater club was to preside at the annual executive committee meeting of the American Canoe Association at the New York Athletic Club in an upcoming weekend meeting. Canoeing was so popular in 1904 that two Cornell students, one of them G. H. Ross of Edgewater, paddled home with a classmate through the Erie Canal and down the Hudson River.

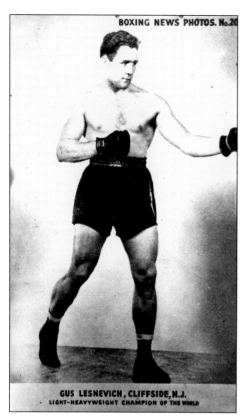

GUS LESNEVICH, CLIFFSIDE, N.J.
LIGHT-HEAVYWEIGHT CHAMPION OF THE WORLD

Gus Lesnevich was a versatile boxer who had an impressive career in the ring, fighting in several weight classes. He was the light heavyweight champion from 1941 until 1948. He may have been known as the Pride of Cliffside, a reference to Cliffside Park, but there was a time in his career when press reports listed Edgewater as his home. Such was the case in March 24, 1938, when Lesnevich gained a decision over Lou Brouillard of Worcester, Massachusetts, former middleweight champion, at the Hippodrome in New York. Steve Dudas was another important fighter from Edgewater in the 1930s and 1940s. From Omaha to Hamburg, Germany, Dudas was a journeyman fighter who was always a contender but never quite a champion. The ring he frequented most was the Ridgewood Grove Sports Club in Brooklyn. He was a good fighter. In 1934, he won 19 fights in a row. Born in 1913, he was still putting up a good fight in the 1940s.

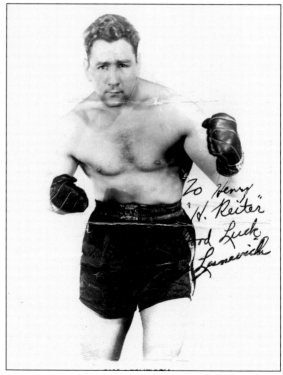